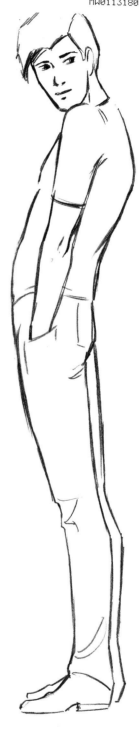

Figure It Out!
Drawing
Essential Poses

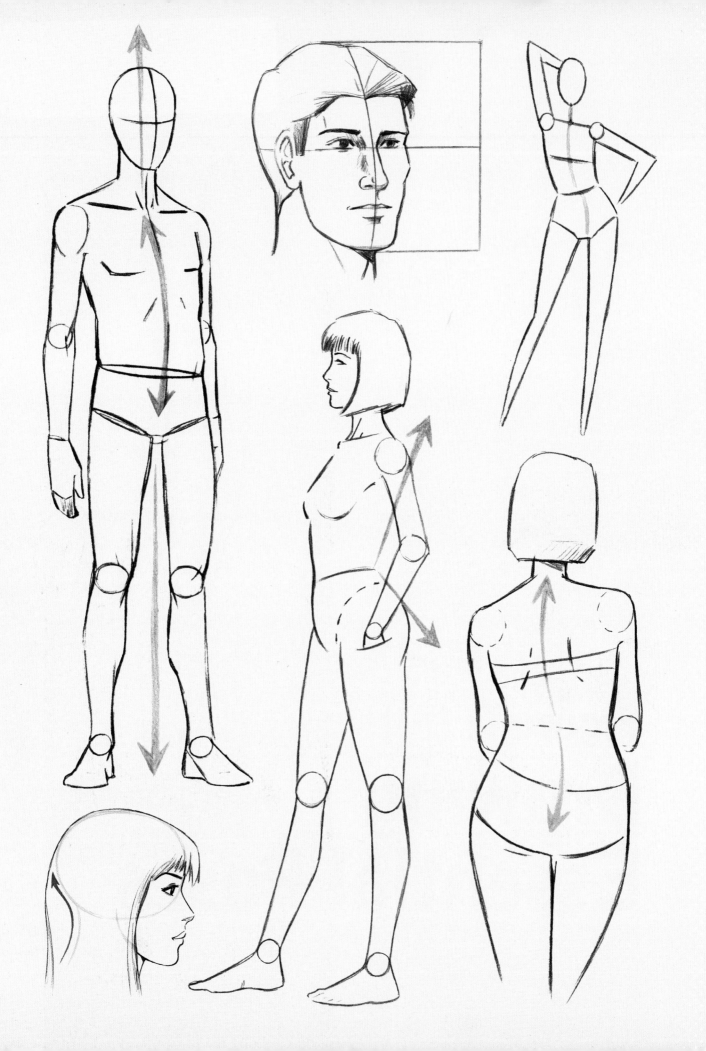

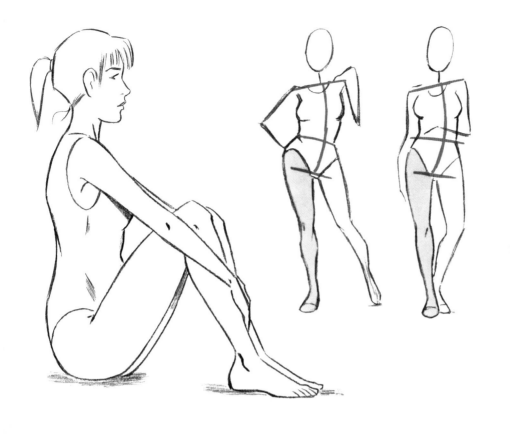

DRAWING WITH **Christopher Hart**

Figure It Out!
Drawing
Essential Poses

THE BEGINNER'S GUIDE TO THE NATURAL-LOOKING FIGURE

sixth&spring books
NEW YORK

DRAWING WITH Christopher Hart

An imprint of Sixth&Spring Books
161 Avenue of the Americas, New York, NY 10013
sixthandspringbooks.com

Editorial Director
JOAN KRELLENSTEIN

Vice President
TRISHA MALCOLM

Managing Editor
LAURA COOKE

Publisher
CAROLINE KILMER

Art Director
DIANE LAMPHRON

Production Manager
DAVID JOINNIDES

Assistant Editor
JACOB SIEFERT

President
ART JOINNIDES

Design
ARETA BUK

Chairman
JAY STEIN

Production
J. ARTHUR MEDIA

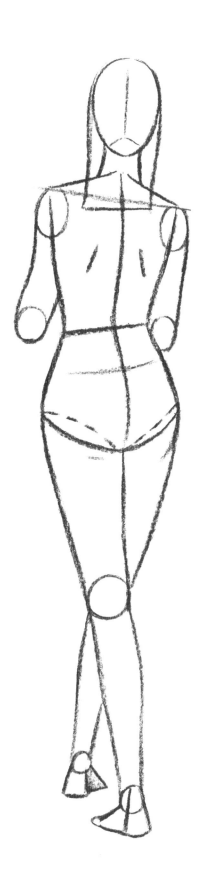

Library of Congress Cataloging-in-Publication Data
Figure it out! drawing essential poses : the beginner's guide to the
natural-looking figure / Christopher Hart.
 pages cm
ISBN 978-1-936096-99-2
1. ART/Techniques/Drawing. 2. ART/Subjects & Themes/Human Figure.
3. ART/Techniques/General.
NC765 .H187 2016
743.4—dc23
 2015042532

Manufactured in China

3 5 7 9 10 8 6 4 2

First Edition

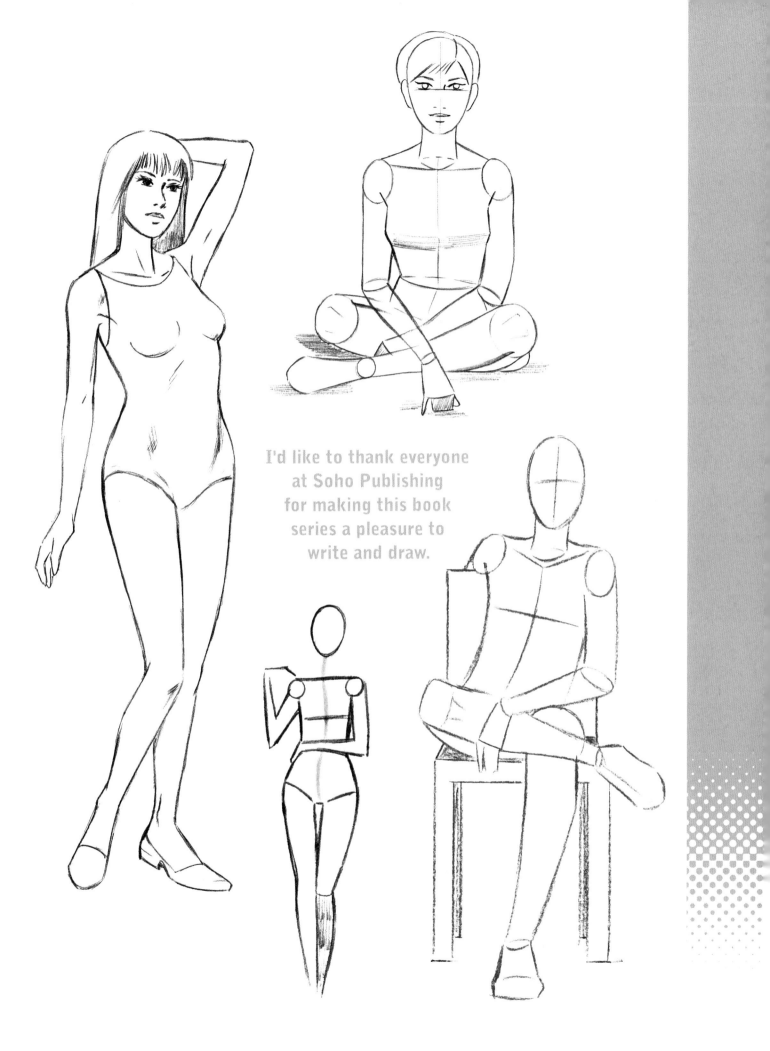

I'd like to thank everyone
at Soho Publishing
for making this book
series a pleasure to
write and draw.

Contents

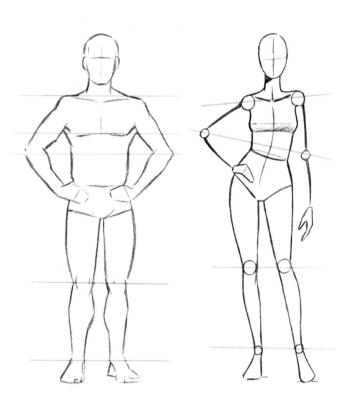

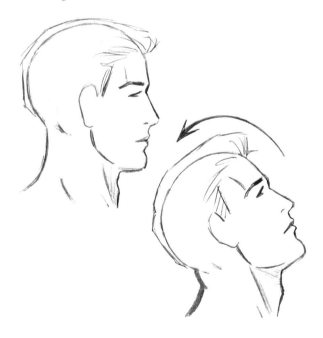

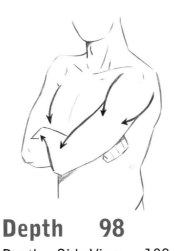

Leg Poses 88

Depth 98

Seated Poses 114

Exercises 128

Introduction

This practical guide will teach you how to draw the types of poses you'll actually use in your artwork. There are no drawings of nudes in improbable positions surrounded by folded fabric. Instead, you'll find realistic poses that are true to the way people carry themselves. If you want your figures to look natural rather than stiff, if you want them to show depth rather than to appear flat, if you want them to be dynamic rather than static, then you need the easy-to-learn techniques contained in this book.

For the aspiring artist who struggles with stiff-looking poses, it's puzzling. Why is it difficult to create a natural looking drawing of someone simply standing? The fact is that there are many forces at play in the human body at all times that work to keep it upright. These forces push and pull against each other. Therefore, there is actually a lot going on in a simple standing pose. I'll show you how to identify these mechanics, and to draw them in a way that is accurate, engaging, and easy to do.

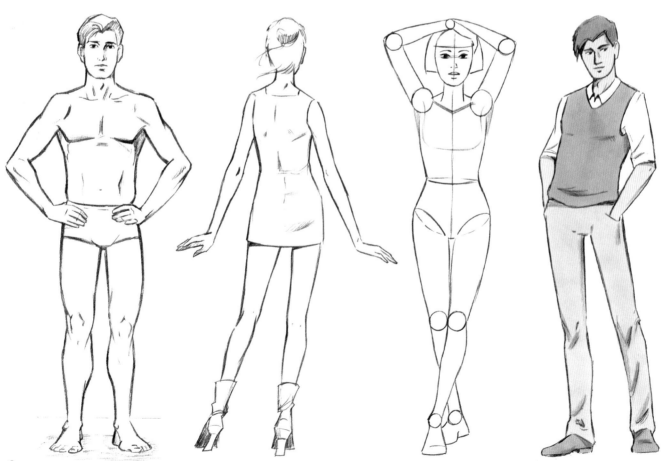

We'll start off with the basics: a chapter on drawing the male and female body. Then we dive into the techniques on poses. The concepts include: drawing the body at different angles, types of posture, the use of counterforces, equilibrium, foreshortening, standing poses, dramatic poses, seated poses, shoulder poses, arm poses, and leg poses. You'll want this useful, complete resource in your art book collection to refer to again and again.

Seemingly difficult gestures, such as drawing the arms folded across the chest, are famous for driving artists nuts. I'll break them down for you, so the only people going nuts are your friends who see that you can draw complex gestures while they can't.

Whether you're a figure-drawing artist, an illustrator, a comics artist, a cartoonist, or a manga artist, this book can transform the way you draw people, making them appear lifelike and engaging. And it's fun, too! So grab a pencil, and let's start drawing.

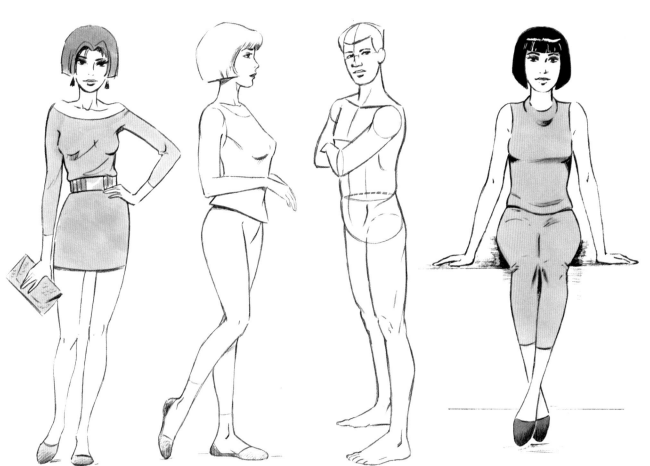

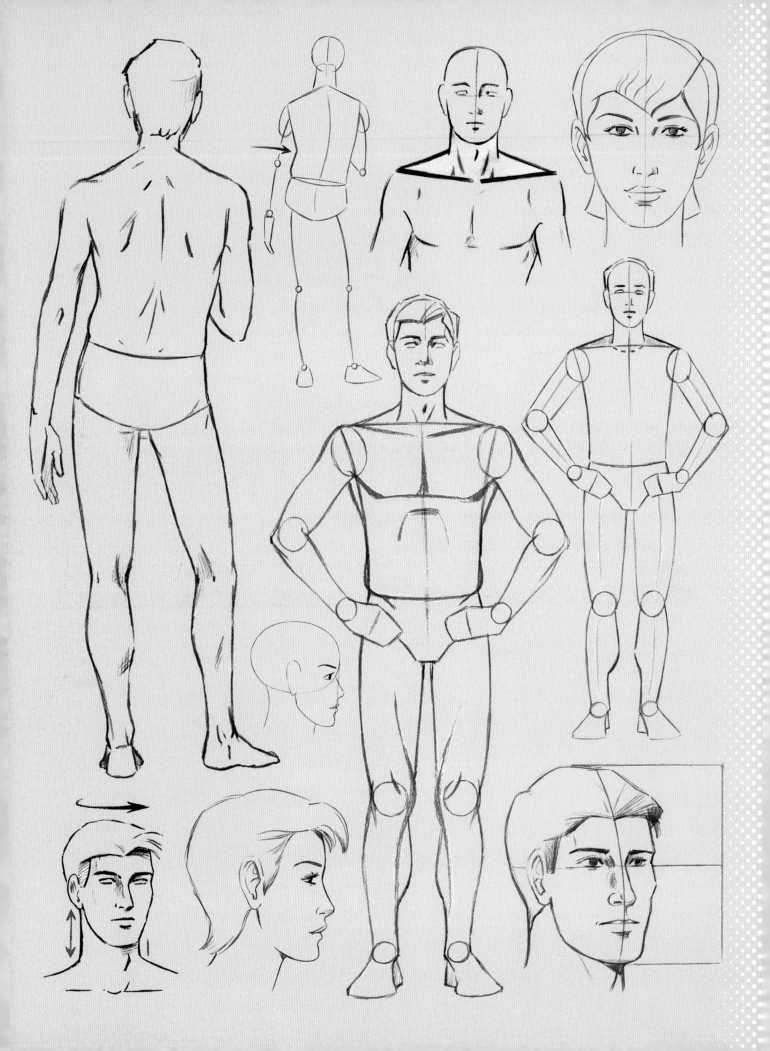

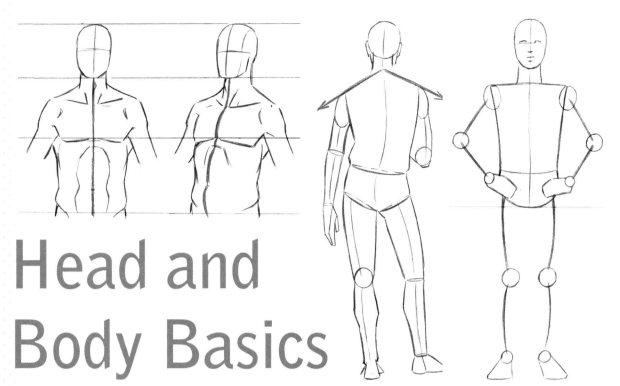

Head and Body Basics

Let's begin with a good warm up for drawing poses: drawing basic heads and bodies. This will give you some important tips about proportion and structure. With a basic knowledge of how to draw the figure, you go on to create poses without the struggle.

Proportions of the Head

The most useful proportion for drawing the head is the placement of the eyes. The rule is that the eyes are drawn halfway up the head.* By establishing this simple proportion at the outset, the rest of the features fall into place. Conversely, if you were to wait until you were well into your drawing to check the proportions, your picture might very well end up like the Leaning Tower of Pisa—a beautiful effort, but with a bad foundation that is hard to hide.

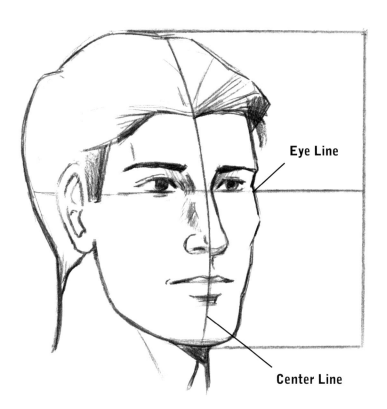

Eye Line

Center Line

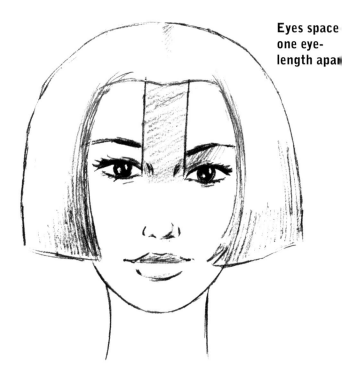

Eyes space one eye-length apar▸

Eye Placement
The eyes are spaced one eye-length apart. This rule of thumb will help you create features that look right as well as consistent.

POSE POINT

The horizontal guideline is called the *Eye Line.* Use it, along with the vertical *Center Line,* to roughly outline your initial drawings or sketches.

*There are many more useful proportions in my book, *Figure It Out: Human Proportions,* which is also published by Sixth&Spring Books.

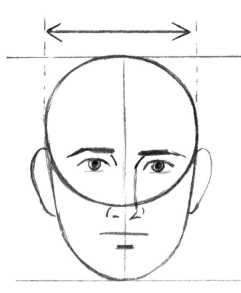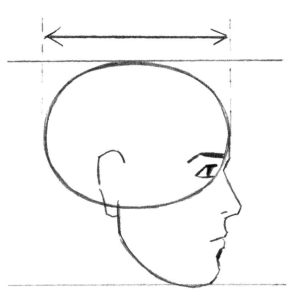

Front View—Slender
The top half of the head
is drawn as a circle.

Side View—Wide
The top half of the head
is drawn as an oval.

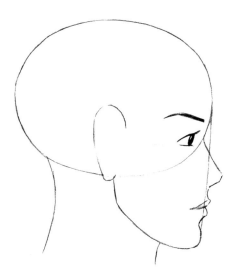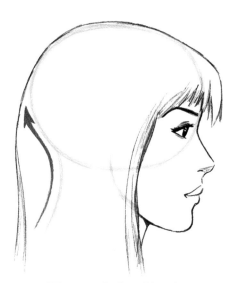

Side View with Neck
The back of the head extends
past the back of the neck.

Flow of the Neck

Side View

In the side view, the head appears wide, and this affects the way the line of the neck is drawn. The neck is thicker than many people think it is, because they are used to seeing it from the front view, which makes it seem thinner. But it's a sturdy section of the body that flows directly into the thick muscles of the upper back.

POSE POINT
The width of the cranium causes the line of the neck to create a pleasing, sweeping curve.

Front View— Male Face

The top half of the head is dome-shaped; it's the bottom half that generally gets people into trouble. Of course, you already know that the jaw tapers to the chin. But do you know where the tapering begins? Let's check it out.

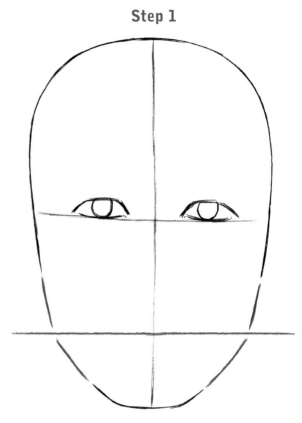

Step 1

The red guideline is drawn at the *angle of the jaw*—the point at which the bottom of the jaw angles inward.

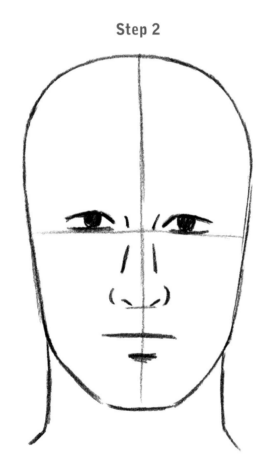

Step 2

Simplified features, mainly for placement.

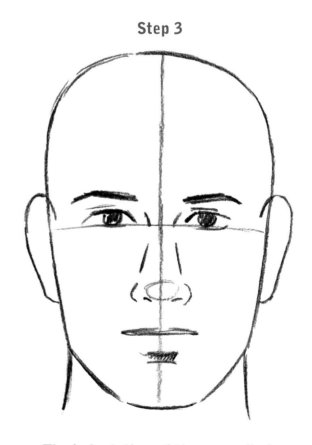

Step 3

The indentation of the upper lip is centered under the nose.

Step 4

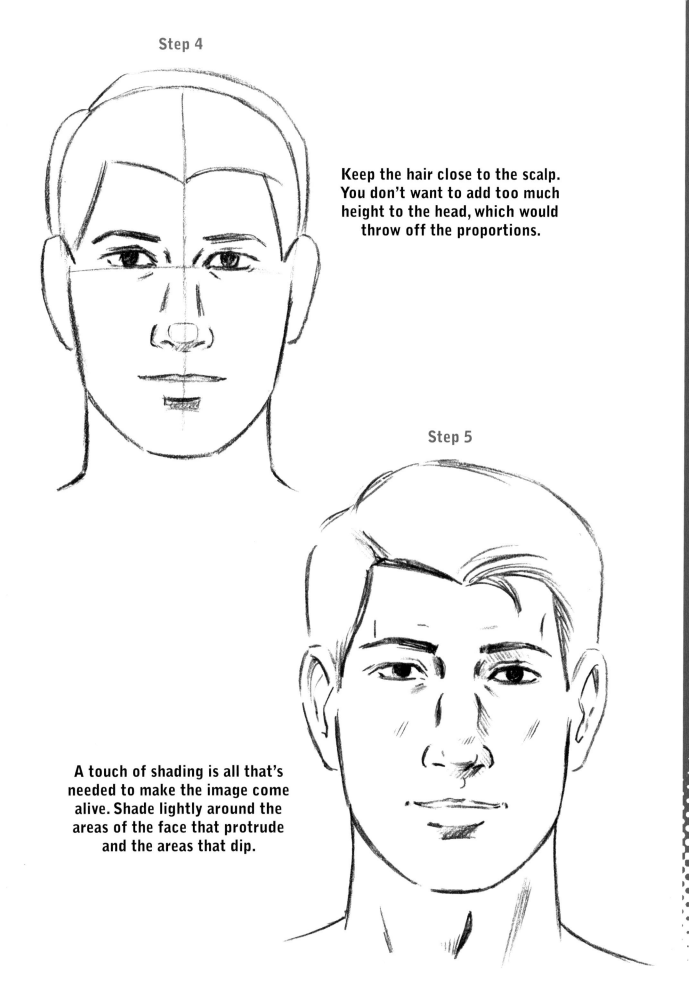

Keep the hair close to the scalp. You don't want to add too much height to the head, which would throw off the proportions.

Step 5

A touch of shading is all that's needed to make the image come alive. Shade lightly around the areas of the face that protrude and the areas that dip.

Front View— Female Face

I like to soften the angle of the jaw on some female faces. However, there's no rule for this. Some female heads are quite tapered, while others have a square look. Therefore, while your approach may vary, the proportions remain the same for everybody.

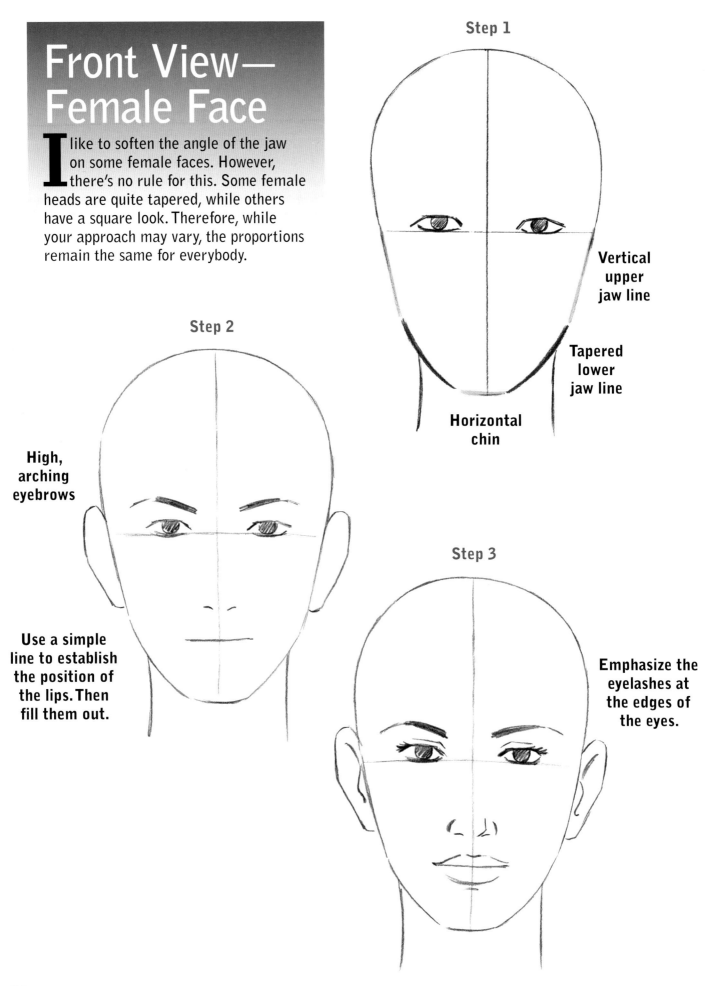

Step 1

Vertical upper jaw line

Tapered lower jaw line

Horizontal chin

Step 2

High, arching eyebrows

Use a simple line to establish the position of the lips. Then fill them out.

Step 3

Emphasize the eyelashes at the edges of the eyes.

Step 4

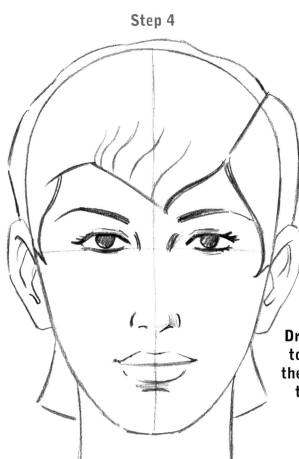

FEATURE FOCUS

Rather than focusing only on the features to draw an interesting face, let the hairstyle do some of the work for you.

Draw lightly to indicate the bridge of the nose.

The eyebrows, the bridge of the nose, and the eyes are drawn with a darker line for emphasis. It makes the eyes the center of attention.

Step 5

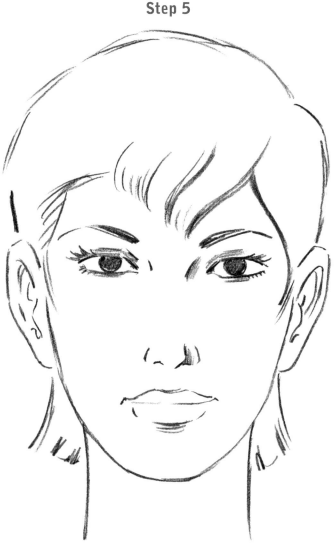

I'm often asked to comment on the drawings of aspiring artists. One thing I've noticed is that expression lines are commonly used on drawings of the face. Unless the subject's face has naturally deep creases, shows signs of age, or is making an expression, these lines can be a distraction. It's better to do too little, than too much.

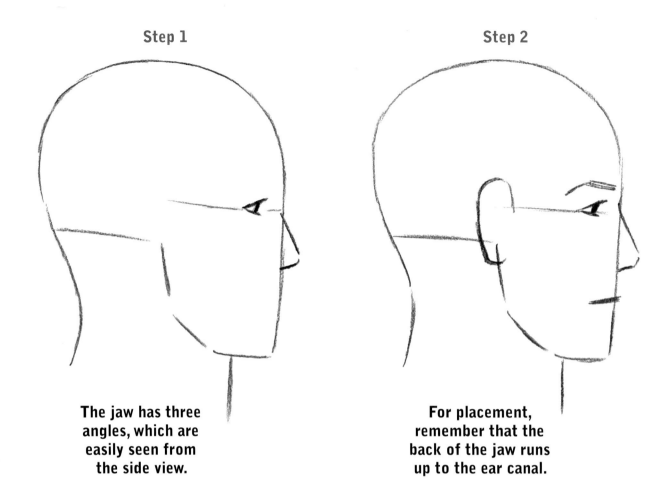

Step 1

The jaw has three angles, which are easily seen from the side view.

Step 2

For placement, remember that the back of the jaw runs up to the ear canal.

Step 3

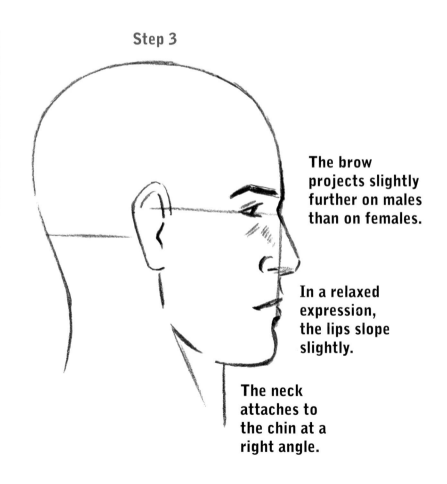

Side View— Male Face

The side view is entirely different from the front view. The features, in the side view, are drawn along the edge of the face. This angle doesn't show much depth, and therefore there's less need for shading.

The brow projects slightly further on males than on females.

In a relaxed expression, the lips slope slightly.

The neck attaches to the chin at a right angle.

18

Step 4

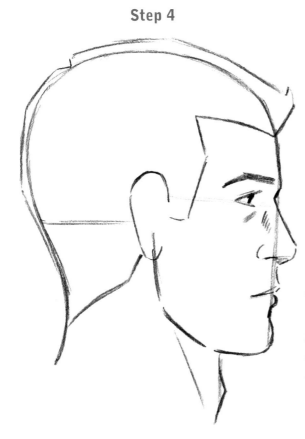

There are two deep indentations at this angle: at the bridge of the nose and between the lower lip and the top of the chin.

Step 5

With the guidelines erased, the features are aligned, and they appear correct.

Side View—Female Face

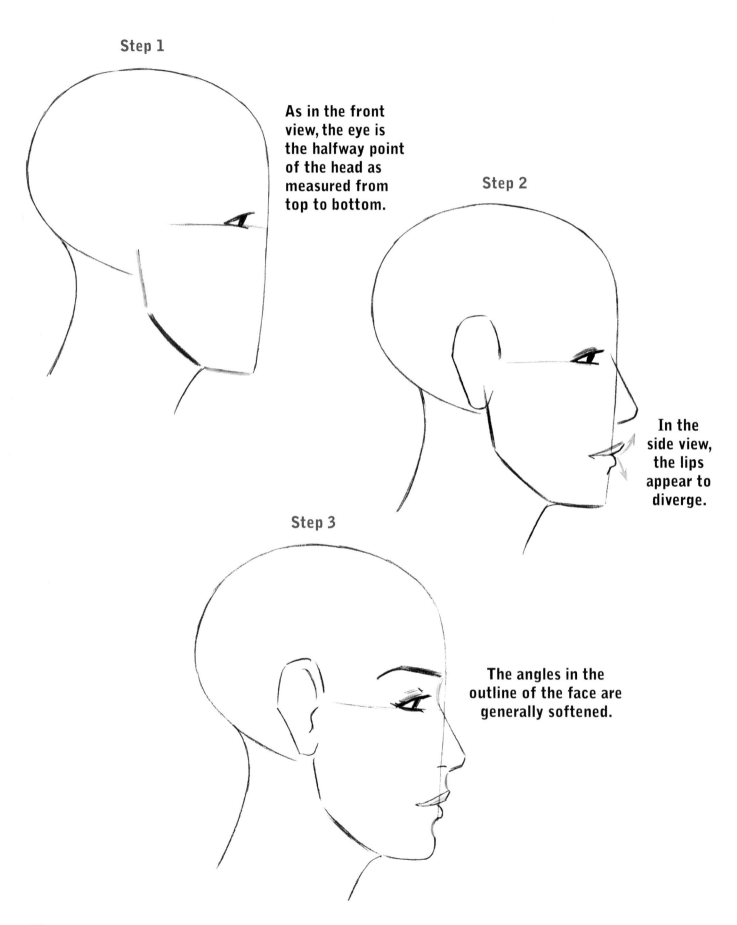

Step 1

As in the front view, the eye is the halfway point of the head as measured from top to bottom.

Step 2

In the side view, the lips appear to diverge.

Step 3

The angles in the outline of the face are generally softened.

Step 4

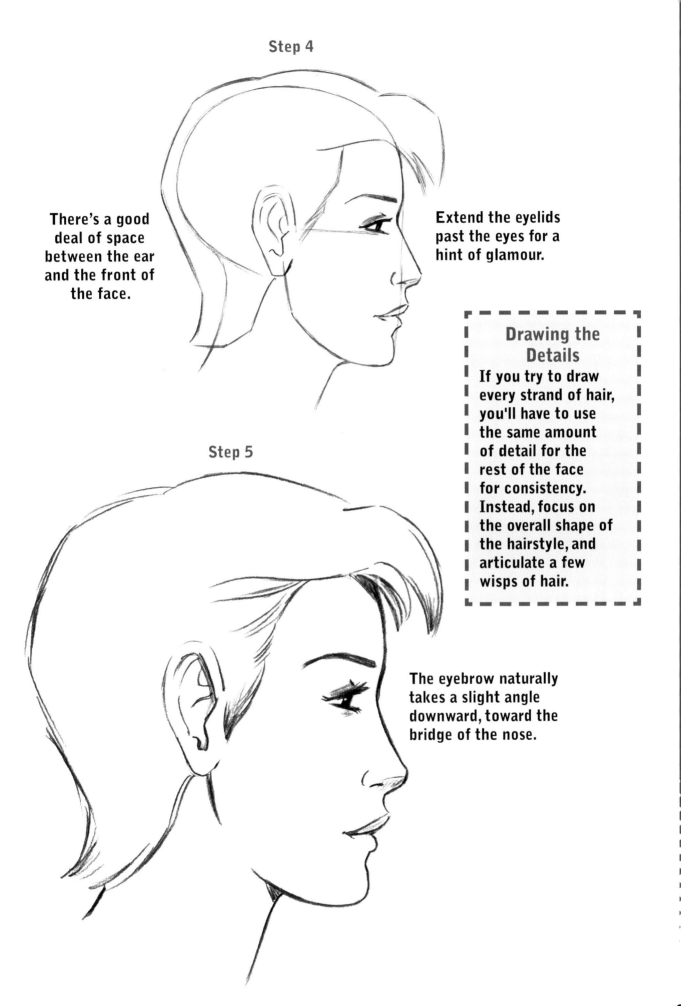

There's a good deal of space between the ear and the front of the face.

Extend the eyelids past the eyes for a hint of glamour.

Drawing the Details

If you try to draw every strand of hair, you'll have to use the same amount of detail for the rest of the face for consistency. Instead, focus on the overall shape of the hairstyle, and articulate a few wisps of hair.

Step 5

The eyebrow naturally takes a slight angle downward, toward the bridge of the nose.

The Head and Neck as a Unit

The head and neck work as one unit; the position of one will always affect the other. When the head tilts, twists, or turns, it puts stress on the neck. We can show this in a variety of ways.

Head Tilt—Side to Side

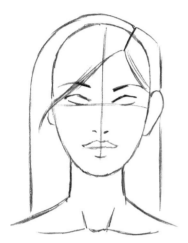 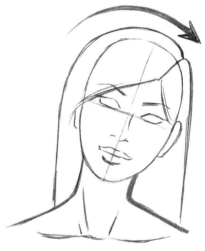

Neutral
Symmetrical

Tilts Left
When the head tilts left, the neck crimps on the left side.

Tilts Right
When the head tilts right, the neck crimps on the right side.

Head Tilt—Forward and Backward

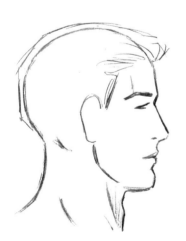 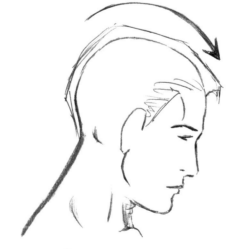 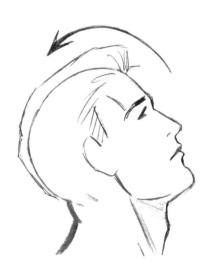

Neutral
Symmetrical

Tilts Forward
When the head tilts forward, the back of the neck and the upper back blend to create a single line, which gives the appearance of length.

Tilts Back
When the head tilts back, the back of the neck crimps, which gives the appearance of a shorter line.

Neck Turns

It's a natural occurrence, in some poses, that the neck appears longer on one side, but shorter on the other. Unfortunately, some people correct for this by making them identical, which looks wrong. Let's follow this simple guide for drawing them so that they'll look right.

Head Neutral
The neck is of even length on both sides.

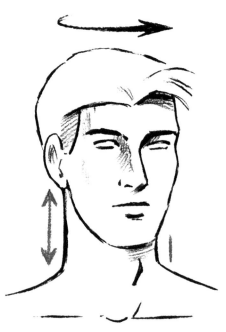

Head Turned Right
The neck appears shorter in the direction that the chin is turned.

◀ POSE POINT

The forward/backward head tilt works differently than the side-to-side tilt in that it primarily affects the way the back of the neck is drawn.

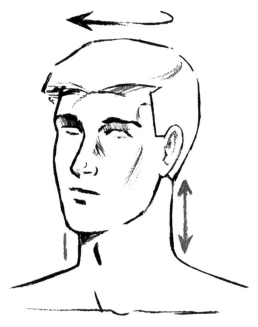

Head Turned Left
The neck appears shorter in the direction that the chin is turned.

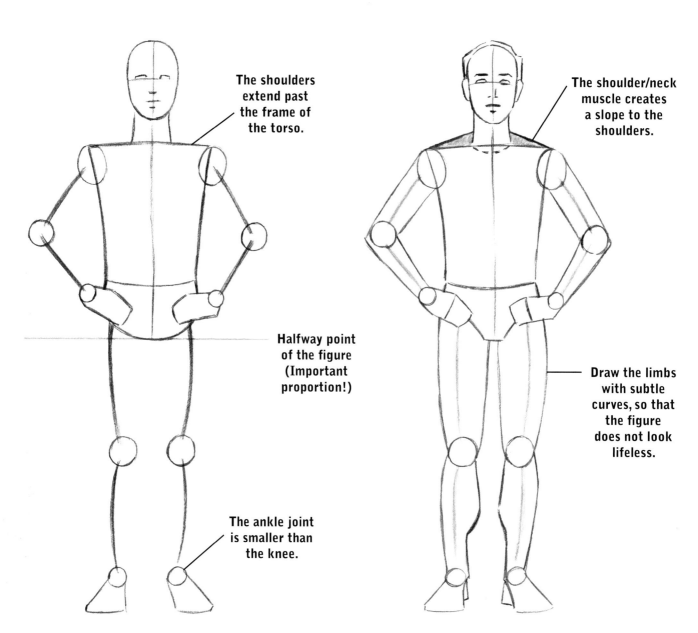

The shoulders extend past the frame of the torso.

The shoulder/neck muscle creates a slope to the shoulders.

Halfway point of the figure (Important proportion!)

Draw the limbs with subtle curves, so that the figure does not look lifeless.

The ankle joint is smaller than the knee.

The Framework

When drawing the basic figure, first sketch the overall form. Make a quick assessment, then make any revisions before you add and define the musculature.

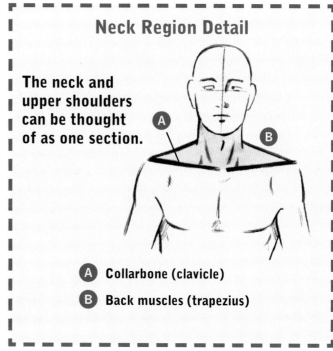

Neck Region Detail

The neck and upper shoulders can be thought of as one section.

Ⓐ

Ⓑ

Ⓐ Collarbone (clavicle)

Ⓑ Back muscles (trapezius)

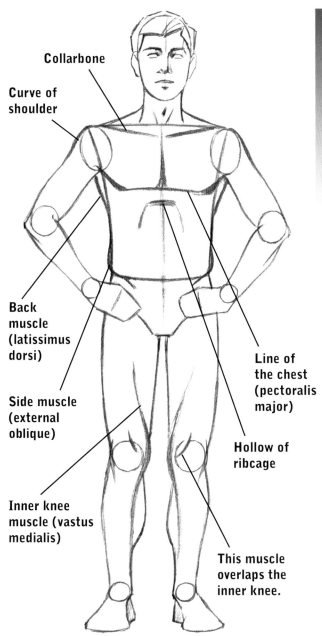

Collarbone

Curve of shoulder

Back muscle (latissimus dorsi)

Side muscle (external oblique)

Inner knee muscle (vastus medialis)

Line of the chest (pectoralis major)

Hollow of ribcage

This muscle overlaps the inner knee.

Drawing the Muscles (Front View)

Even a well-posed figure needs some definition. This is done by suggesting the shape and location of the muscles, bones, and ligaments. And yes, this can also be suggested on clothed figures as well, as we will soon see.

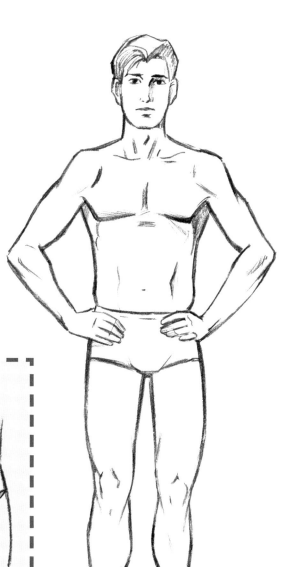

Hip Detail

Simplify the pelvis by drawing it as a bathing suit, which will emphasize its depth.

Ⓐ Draw the top of the hips to show depth (gray area).

Ⓑ The holes for the legs are drawn on a diagonal.

Back View

Because of its width, the back view can be a powerful-looking pose. When the shoulder blades are spaced well apart, a broad look is emphasized. Unless it is flexed or heavily muscled, the back is generally less well articulated than the front of the torso.

The shoulder muscles pyramid at the big joint at the back of the neck (the 7th vertebrae).

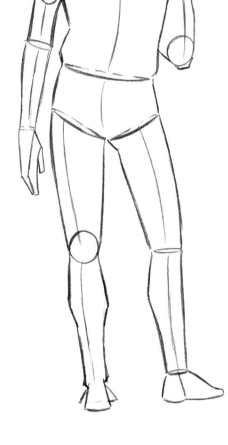

Any bend in the torso occurs just under the ribcage.

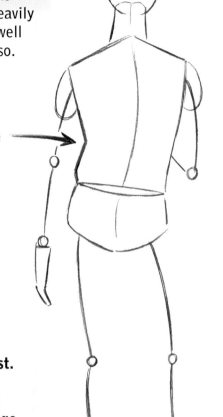

POSE POINT

For variety, add a bend to the waist. In upcoming chapters, you'll see how this slight variation becomes the key element across a wide range of poses.

Drawing Other Angles

If every drawing of the figure were a front view, things would get pretty boring. So it's necessary to know how to draw the body from different angles. Let's see what happens to the figure when we turn it from a front view to a three-quarter view.

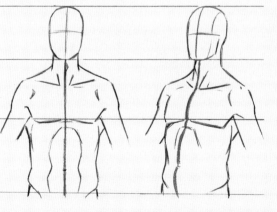

Front View
The centerline is perfectly straight.

Three-Quarter View
When we turn the body, the Center Line becomes bumpy, articulating the various contours along the torso.

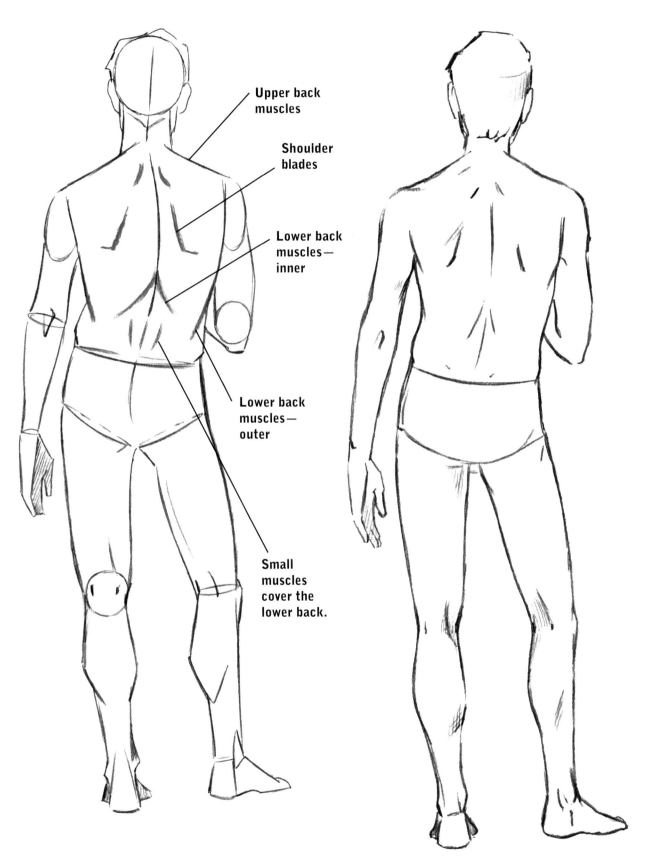

Upper back
muscles

Shoulder
blades

Lower back
muscles—
inner

Lower back
muscles—
outer

Small
muscles
cover the
lower back.

**Final Back-View Drawing
with Muscle Definition**

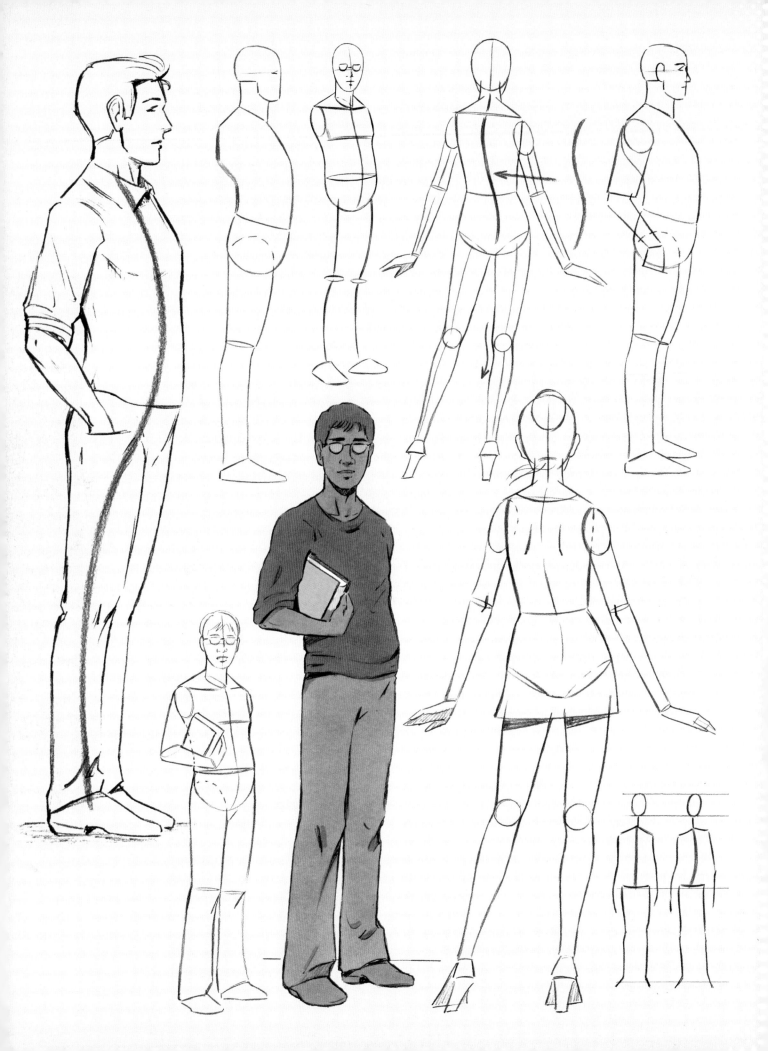

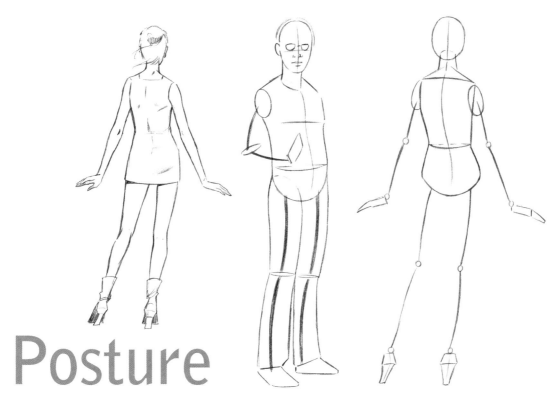

Posture

You'd think it would be easy to draw an ordinary standing pose, but there's actually a lot going on with the body that occurs when a person is simply standing still. If these elements are not incorporated, the result can be a stiff-looking figure. This chapter on posture will give you the tools you need to draw natural-looking standing poses.

Classic Posture (Side View)

In order to portray someone standing up straight, you need to draw curves. Sounds wrong, but it's true. Let's compare what happens when you use straight lines versus curved lines to create posture.

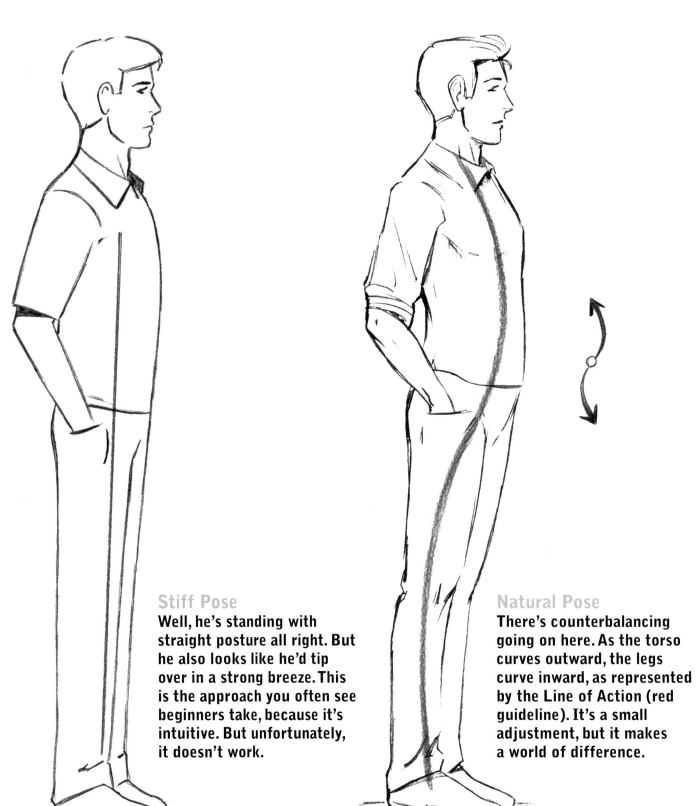

Stiff Pose
Well, he's standing with straight posture all right. But he also looks like he'd tip over in a strong breeze. This is the approach you often see beginners take, because it's intuitive. But unfortunately, it doesn't work.

Natural Pose
There's counterbalancing going on here. As the torso curves outward, the legs curve inward, as represented by the Line of Action (red guideline). It's a small adjustment, but it makes a world of difference.

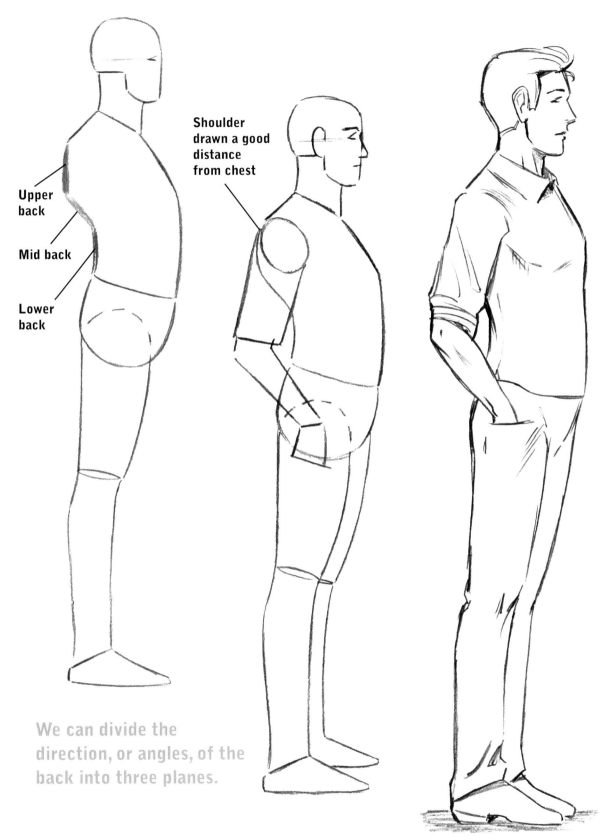

Upper
back

Mid back

Lower
back

Shoulder
drawn a good
distance
from chest

We can divide the
direction, or angles, of the
back into three planes.

POSE POINT

**To look comfortable, the posture needs
to show an overall flow.**

To the average viewer, this
figure appears to be standing
straight, but it's actually built
on a series of curves.

How Real People Stand

The classic posture, outlined on the previous page, is the way you stand when your doctor measures your height. In real life, the body relaxes and settles. This causes the hips to move forward and the chest to sink. Let's try it.

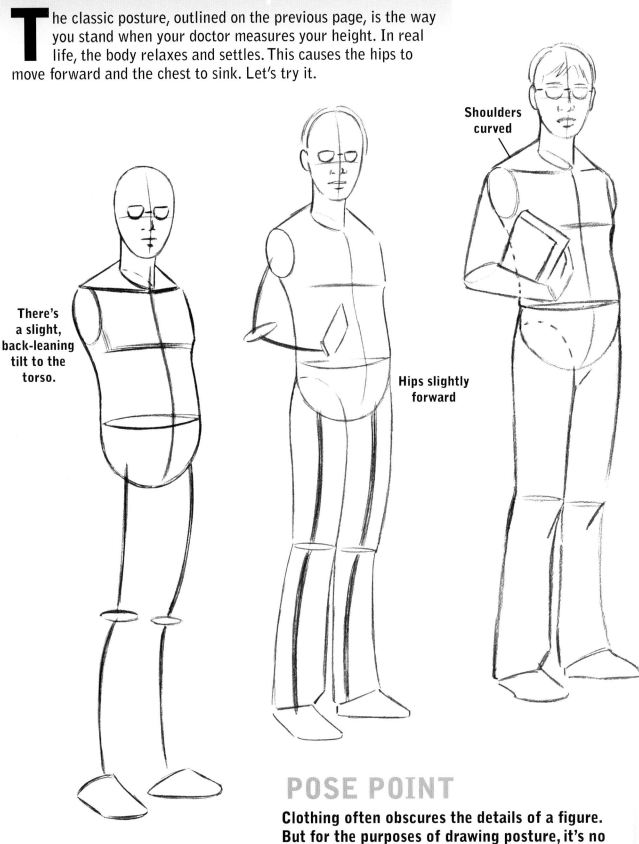

There's a slight, back-leaning tilt to the torso.

Shoulders curved

Hips slightly forward

POSE POINT

Clothing often obscures the details of a figure. But for the purposes of drawing posture, it's no impediment. The overall flow of the pose creates the impression, not individual pieces of clothing.

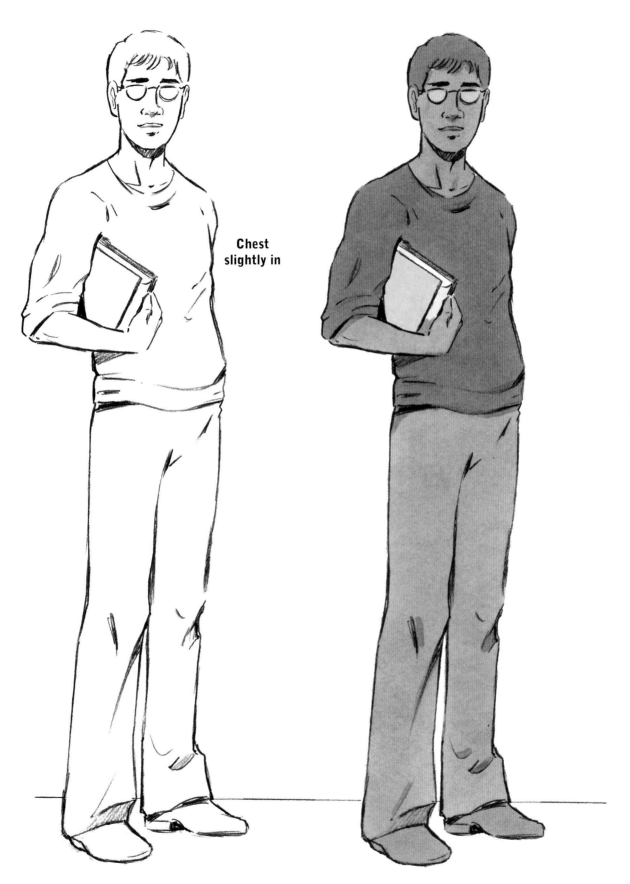

Chest
slightly in

Finished drawing with
color added

Back View (Posture)

When the body is relaxed, the pose looks natural. Create a flow between the upper and lower bodies so that they move as a flexible unit.

Spine Comparison

Straight spine— meh.

Flexible spine— yeah!

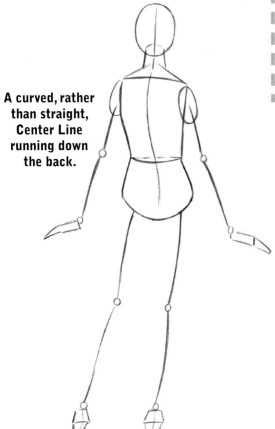

A curved, rather than straight, Center Line running down the back.

Instead of drawing a static stick figure as a starting point, we'll incorporate the posing principles from the very beginning.

POSE POINT

The Center Line dictates the position of the upper and lower body. Note how the hips shift slightly right, while the upper body shifts slightly left—just like the Center Line.

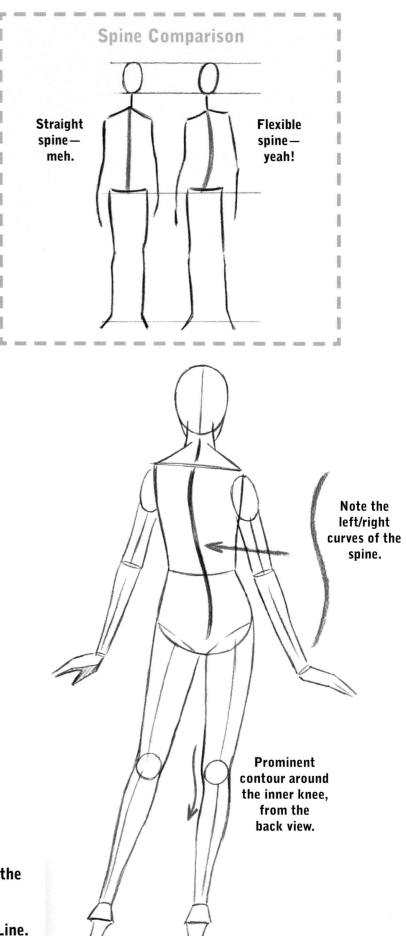

Note the left/right curves of the spine.

Prominent contour around the inner knee, from the back view.

34

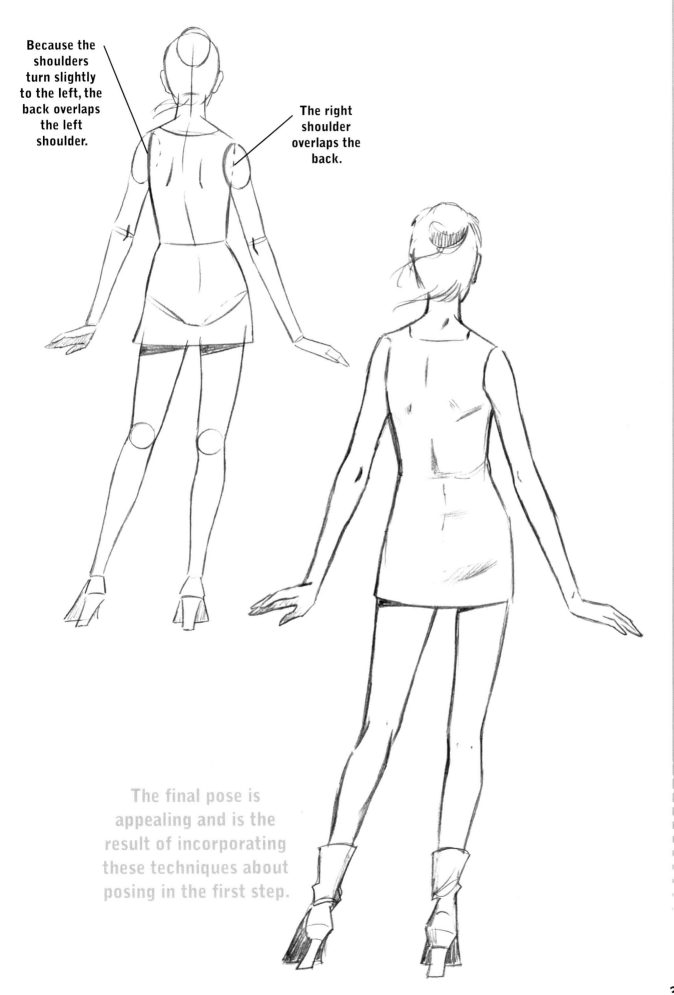

Because the shoulders turn slightly to the left, the back overlaps the left shoulder.

The right shoulder overlaps the back.

The final pose is appealing and is the result of incorporating these techniques about posing in the first step.

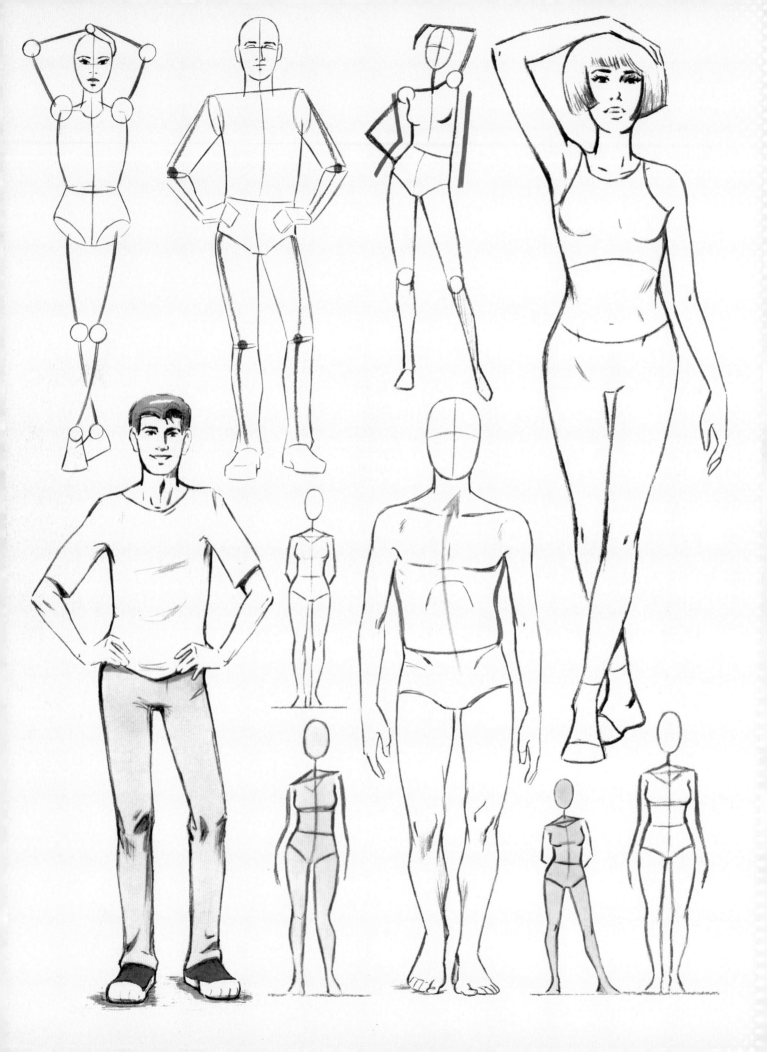

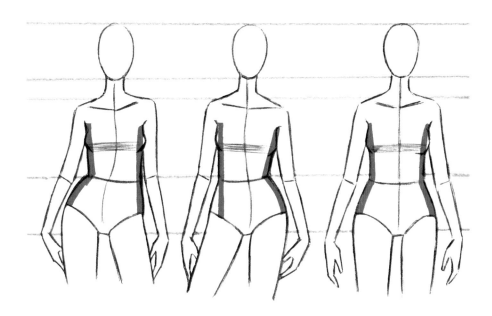

The Must-Know Info

Having covered some important basics in the first two chapters, we're now going to take the next step. The must-know techniques in this section will give you highly effective tools to work with. The concepts are clearly illustrated and carefully described in order to make them easy to understand. By adding these approaches to your skill set, you will actually *simplify* things, not make them more complicated.

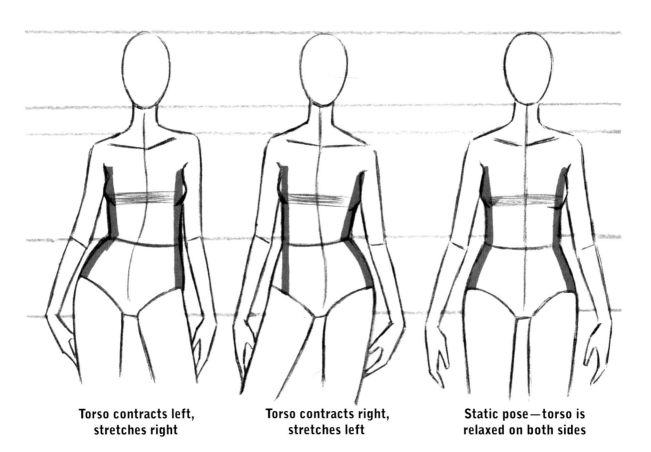

Torso contracts left, stretches right

Torso contracts right, stretches left

Static pose—torso is relaxed on both sides

Contracting and Stretching

An obvious way to avoid drawing a stiff figure is to put a bend in it. Add a bend at the waistline on one side. On the other side, stretch the torso. The contrast between the two sides of the torso creates the appealing look.

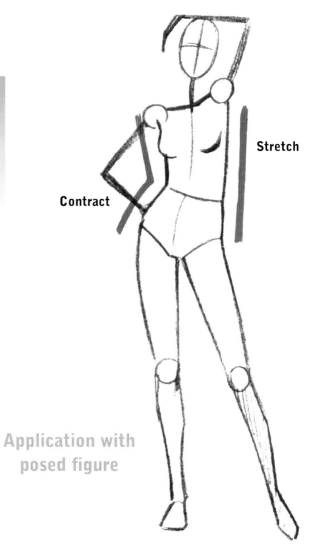

Stretch

Contract

Application with posed figure

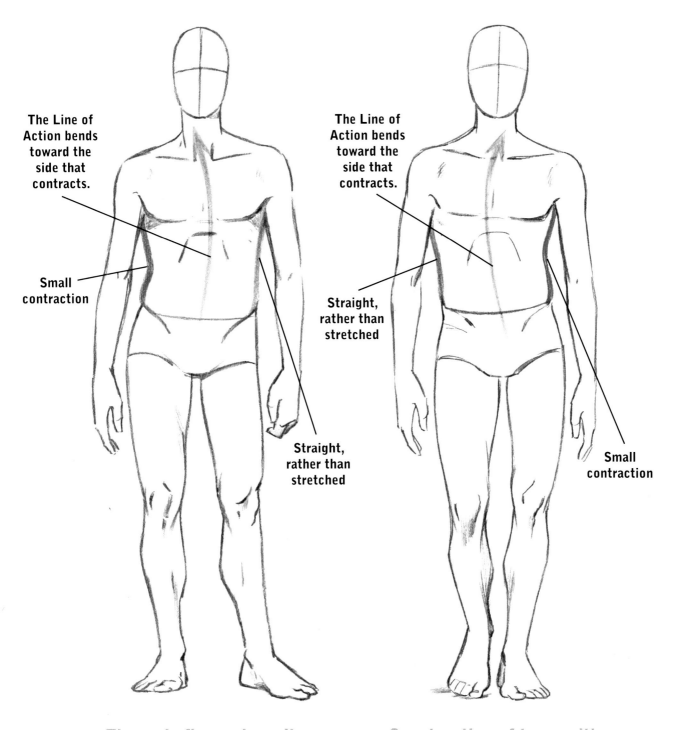

The Line of
Action bends
toward the
side that
contracts.

Small
contraction

Straight,
rather than
stretched

The Line of
Action bends
toward the
side that
contracts.

Straight,
rather than
stretched

Small
contraction

The male figure doesn't always exhibit the same degree of contraction in a pose as the female figure. But even the subtle application of this principle is enough to significantly increase the appeal of a pose.

Construction of torso with contraction on opposite side

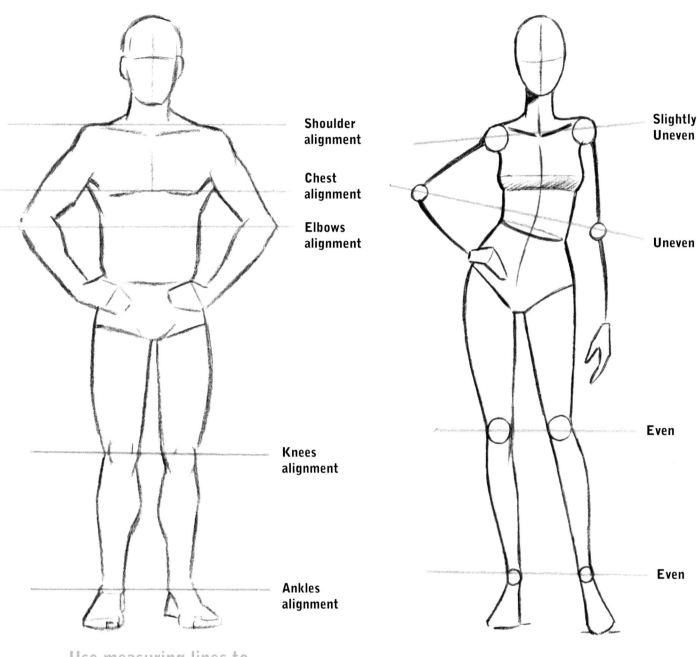

Shoulder
alignment

Chest
alignment

Elbows
alignment

Knees
alignment

Ankles
alignment

Slightly
Uneven

Uneven

Even

Even

Use measuring lines to
avoid a lopsided drawing.

POSE POINT

**Even when the body is drawn unevenly,
much of it still remains in alignment.**

Alignment

By lightly sketching guidelines across the important points along a figure,
you create a simple grid for keeping the body in alignment. However,
many poses are intentionally drawn out of alignment in order to create a
dramatic look. In such cases, other areas of the body can remain unaffected, such
as knees and ankles.

Change of Angles

Here is a simple standing pose, which I've drawn in silhouette to highlight an important principle: simply by turning the figure from a front pose to a three-quarter pose, the overall effect is more engaging. The takeaway is this: if your pose appears static, keep the pose but adjust the angle!

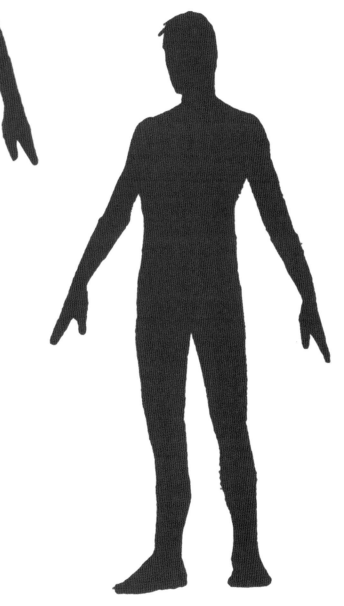

Static
(Front View)

Dynamic
(¾ View)

Creating Variations

Changing the positions of the arms, legs, or both is an excellent way to create variations in poses. Another is to shift the weight slightly to one side or the other, bend a knee inward, or move a leg nearer or further from the body. Even a slight shift can create a more dramatic pose.

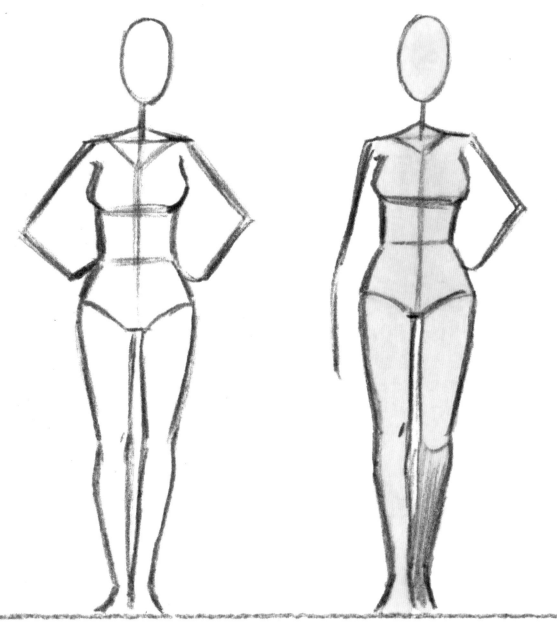

Static

Variation: arm down,
leg slightly bent

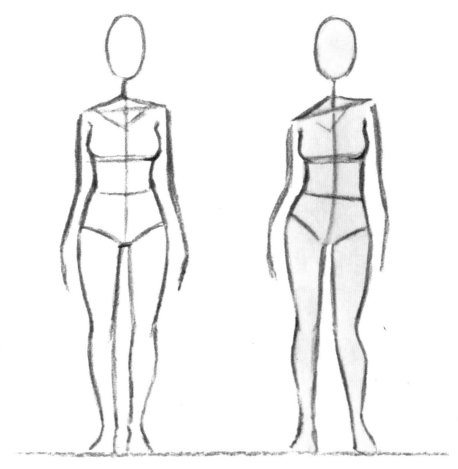

Static

Variation: shoulder dips and leg bends inward

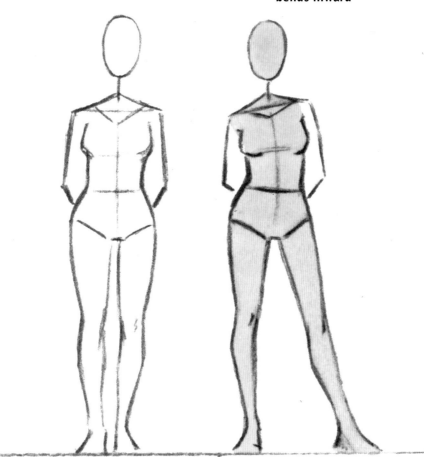

Static

Variation: leg away

Arranging Arms and Legs

This pose may not appear basic, but it is. She's standing with her weight distributed evenly without so much as a bend at the waist. The pose is completely symmetrical. So what gives it a dramatic look? The bold placement of the arms and legs.

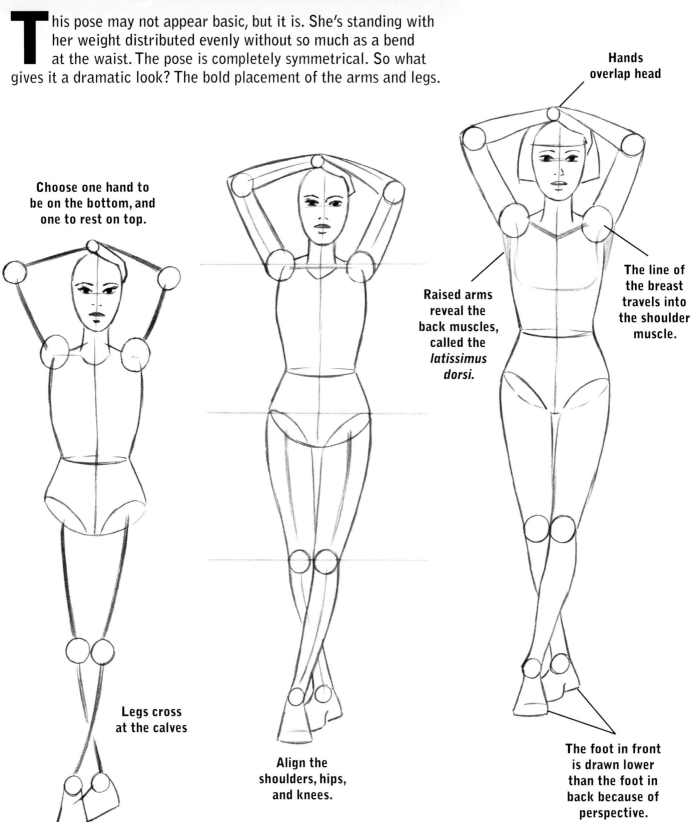

Hands overlap head

Choose one hand to be on the bottom, and one to rest on top.

Raised arms reveal the back muscles, called the *latissimus dorsi*.

The line of the breast travels into the shoulder muscle.

Legs cross at the calves

Align the shoulders, hips, and knees.

The foot in front is drawn lower than the foot in back because of perspective.

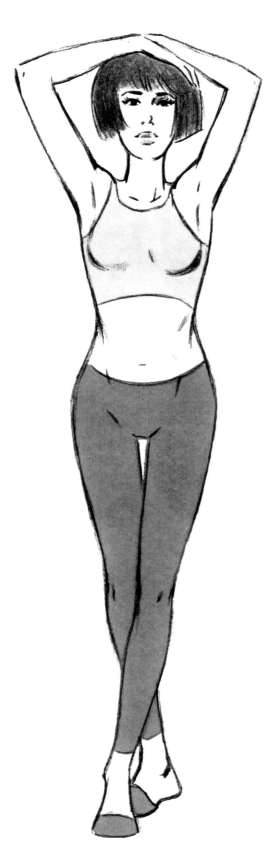

Though it's a static pose, the position of the limbs gives it a cool look.

Creating Variations

To create new poses, reinvent existing ones. It doesn't take a big revision to achieve a legitimate, new pose. Something as simple as raising or lowering a limb can do it.

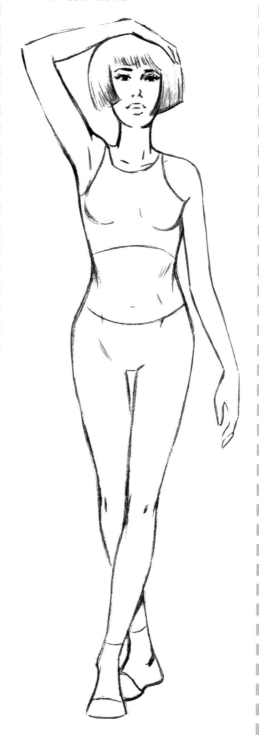

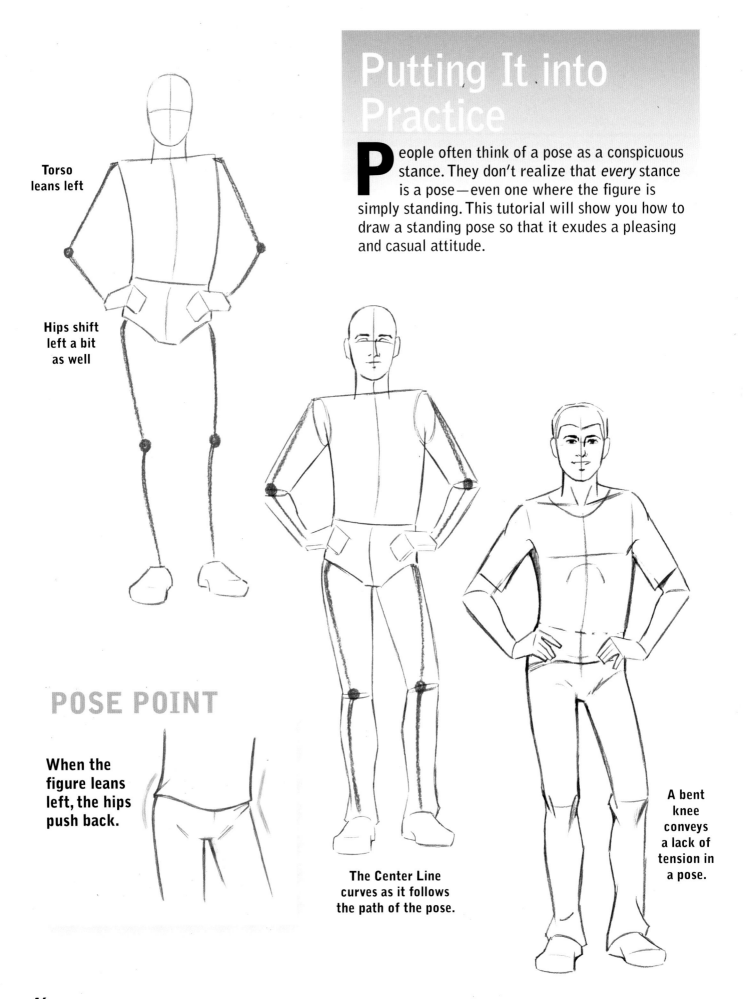

Putting It into Practice

People often think of a pose as a conspicuous stance. They don't realize that *every* stance is a pose—even one where the figure is simply standing. This tutorial will show you how to draw a standing pose so that it exudes a pleasing and casual attitude.

Torso leans left

Hips shift left a bit as well

POSE POINT

When the figure leans left, the hips push back.

The Center Line curves as it follows the path of the pose.

A bent knee conveys a lack of tension in a pose.

> ## Don't Overdo It
> We've covered many techniques in this chapter, but it isn't necessary, or even advisable, to try to use all of them in every drawing you create. Keep it simple, and the results will be better.

A relaxed pose makes the figure appear friendly and approachable.

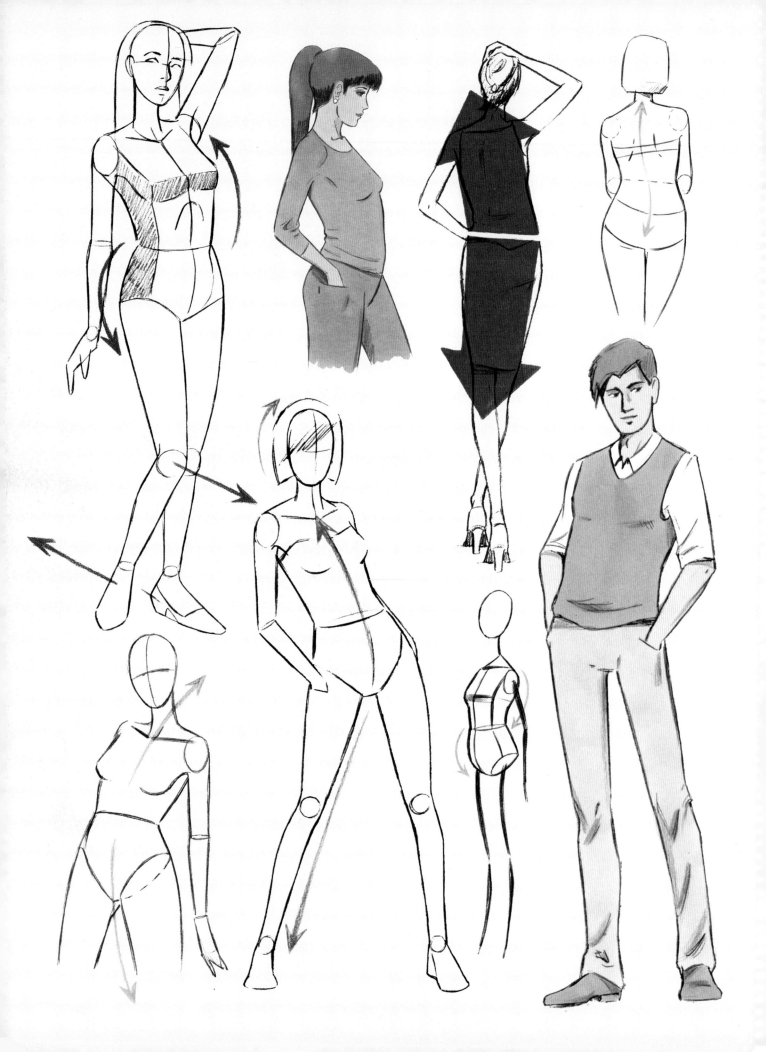

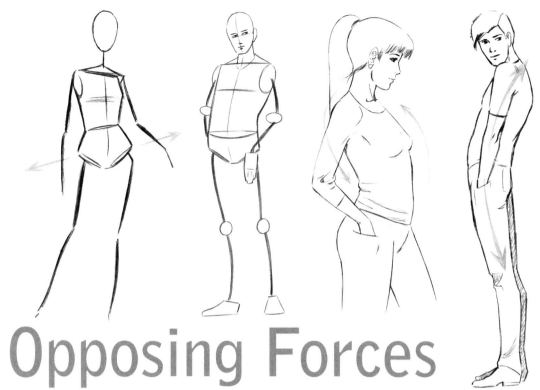

Opposing Forces

When a pitcher throws a ball, it's obvious that there's a lot of force behind the action. But there's force behind every action, and behind every pose, no matter how small. Identifying those forces is the job of the figure-drawing artist. By using lines of force and thrust to our advantage, we can create poses that are compelling and even dramatic.

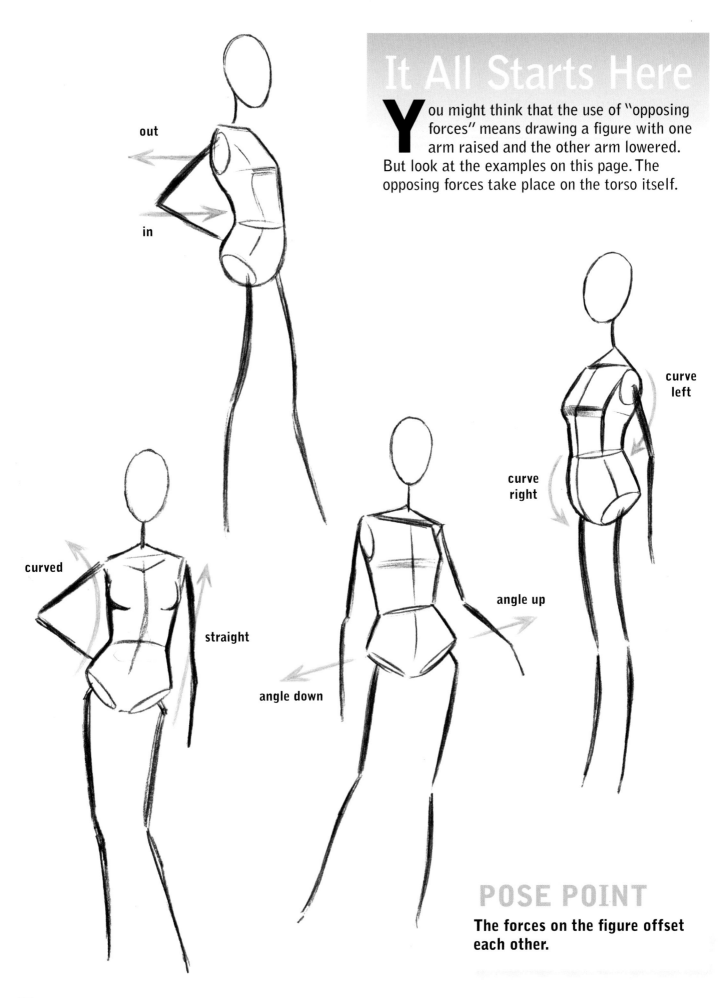

out

in

It All Starts Here

You might think that the use of "opposing forces" means drawing a figure with one arm raised and the other arm lowered. But look at the examples on this page. The opposing forces take place on the torso itself.

curve left

curve right

curved

straight

angle up

angle down

POSE POINT

The forces on the figure offset each other.

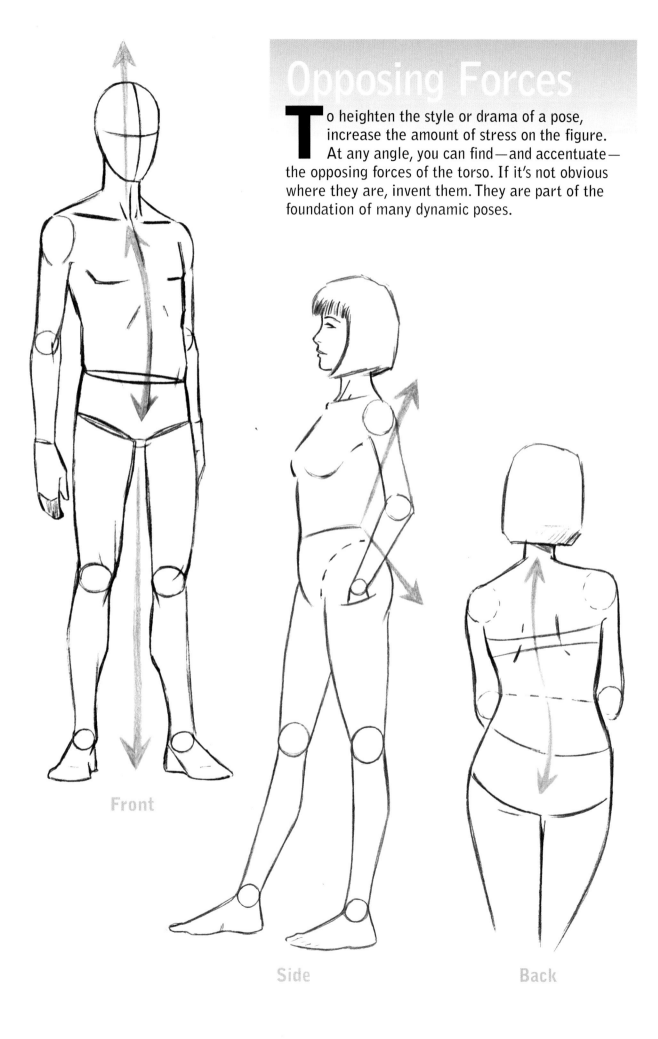

Opposing Forces

To heighten the style or drama of a pose, increase the amount of stress on the figure. At any angle, you can find—and accentuate—the opposing forces of the torso. If it's not obvious where they are, invent them. They are part of the foundation of many dynamic poses.

Front

Side

Back

When the figure leans in one direction, one or more opposing forces must lean in the other direction to offset it. All of these forces create a dramatic look, even if the sum of the forces equals zero.

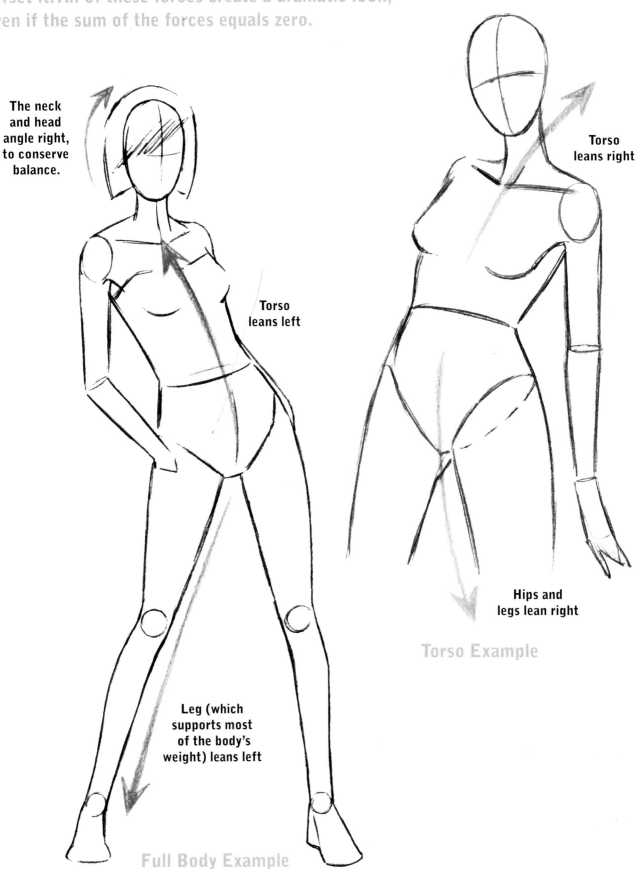

The neck and head angle right, to conserve balance.

Torso leans left

Torso leans right

Hips and legs lean right

Torso Example

Leg (which supports most of the body's weight) leans left

Full Body Example

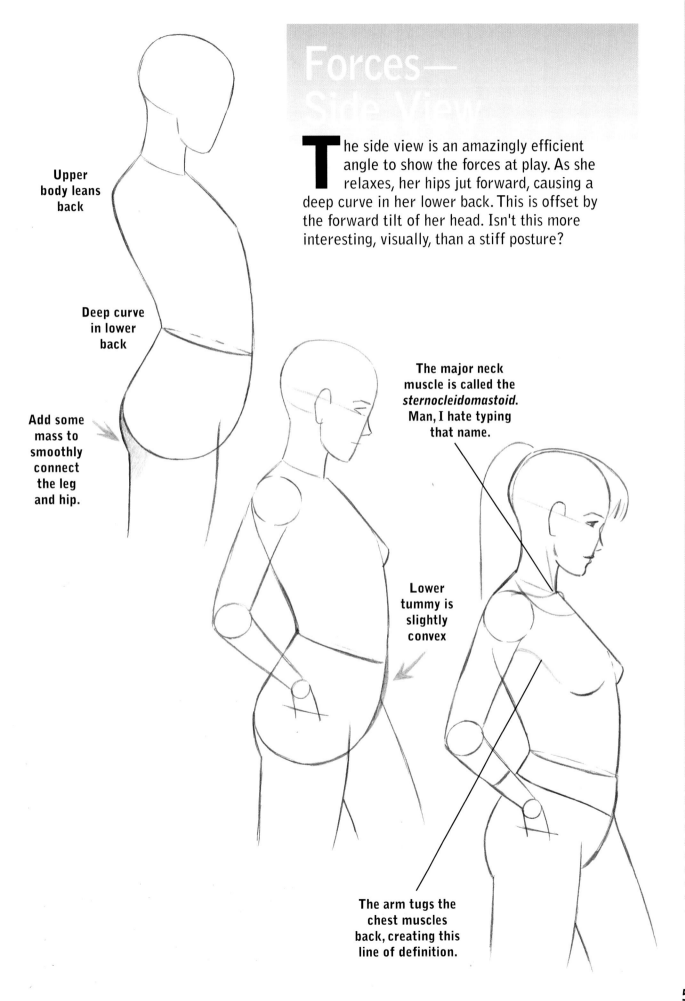

Forces—
Side View

The side view is an amazingly efficient angle to show the forces at play. As she relaxes, her hips jut forward, causing a deep curve in her lower back. This is offset by the forward tilt of her head. Isn't this more interesting, visually, than a stiff posture?

Upper body leans back

Deep curve in lower back

Add some mass to smoothly connect the leg and hip.

The major neck muscle is called the *sternocleidomastoid*. Man, I hate typing that name.

Lower tummy is slightly convex

The arm tugs the chest muscles back, creating this line of definition.

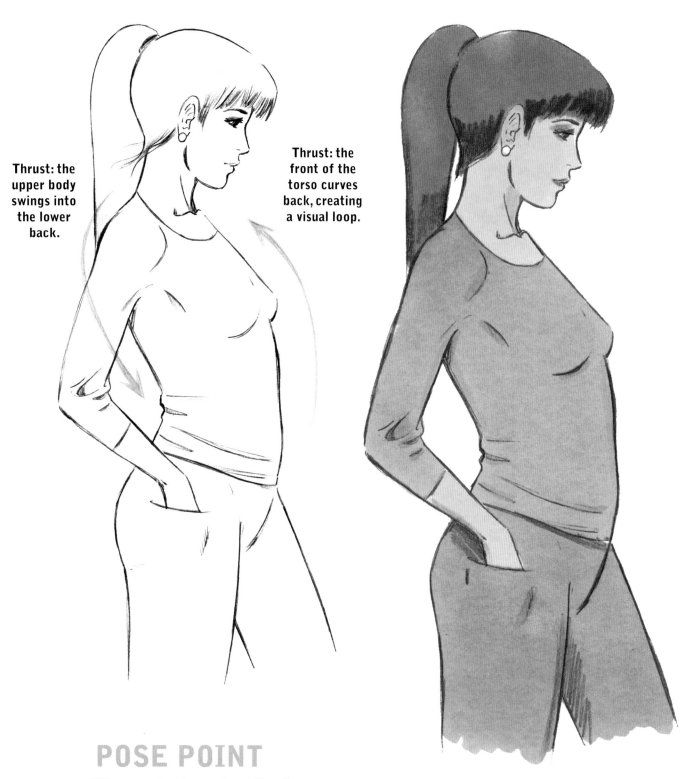

Thrust: the upper body swings into the lower back.

Thrust: the front of the torso curves back, creating a visual loop.

POSE POINT

When we begin to draw the figure, we usually start by blocking out the foundation, using general guidelines and shapes. However, the effects on the body of these opposing forces should be apparent in the finished pose, without guidelines.

More on Posture

The more fluid the line of the figure, the more natural the pose. We can use this principle to our advantage. The figure of the man on the left, which is drawn without opposing forces, is stiff. But so is the character. He looks downtrodden, introverted and stationary. Therefore, the lack of opposing forces reflects his state of mind, making the pose effective.

The man on the right, drawn on a foundation of opposing forces, has an approachable, friendly disposition. The flexibility of his pose reflects an easygoing personality.

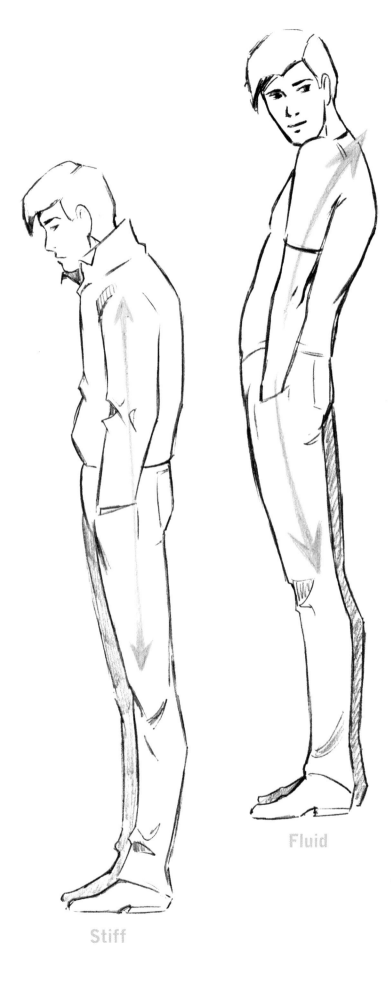

Fluid

Stiff

Drawing Exercise:
Full Figure, Side

The key to drawing poses is to blend the various sections that make up the body into a pleasing whole. Streamline your poses so that they don't appear to be a series of stacked segments.

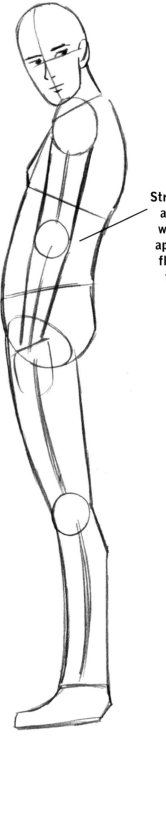

Straighten the arm, which will make it appear to lie flat against the body.

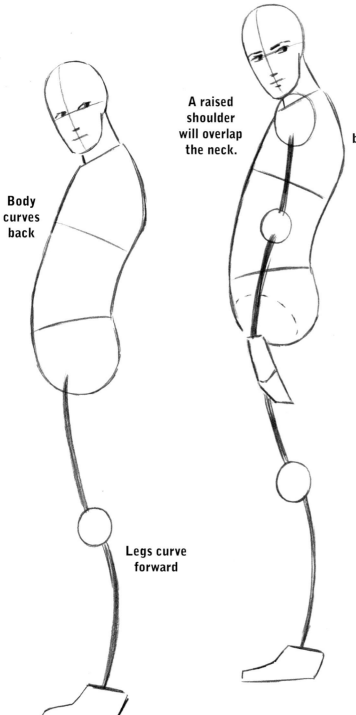

A raised shoulder will overlap the neck.

The upper back provides the longest, continuous line of the figure.

Body curves back

Legs curve forward

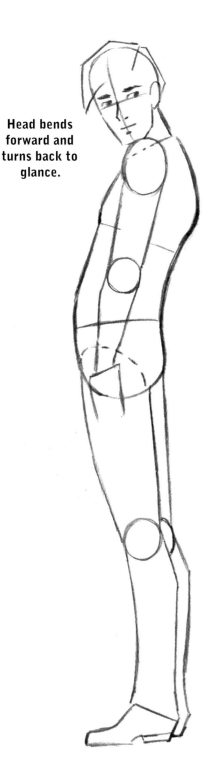

Head bends forward and turns back to glance.

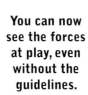

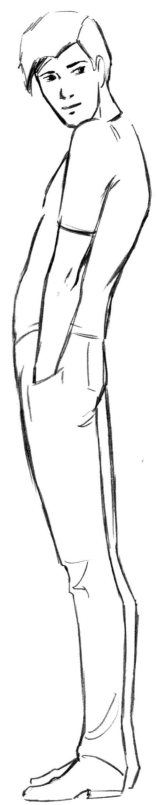

You can now see the forces at play, even without the guidelines.

Once you've roughed out the general thrust of the framework of the body, flesh out the arms and legs. The forces we've been utilizing affect the larger areas of the body. Smaller areas can remain unaffected. For example, this figure's arm doesn't appear to be participating in our little demonstration of opposing forces!

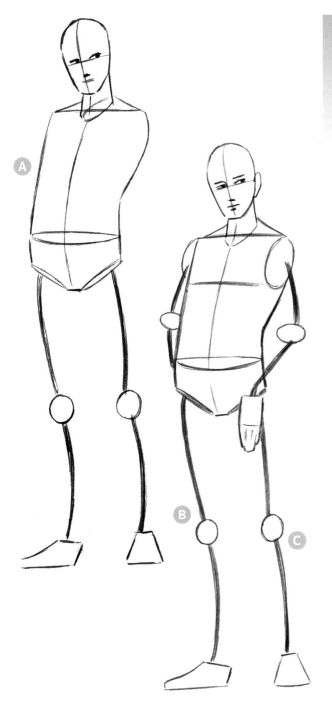

A flowing force gives a pose an element of style. Often, as artists, we are required to draw figures that are not engaged in a purposeful action. And yet, we want them to look interesting. This is an effective way to make a pose look good when there is no specific action associated with it.

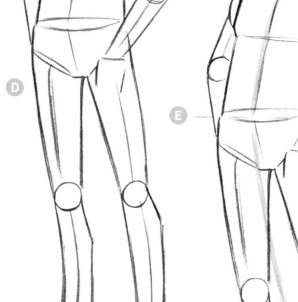

(A) The bend in the lower back forces the front of the torso to stretch and flatten out.

(B) Curvier (because it is drawn in a side view)

(C) Straighter (because it is drawn in a front view)

(D) Flesh out the arms and limbs.

(E) The waist becomes the fulcrum—a neutral place—for the purposes of plotting out the opposing forces of the figure.

(F) When the head tilts forward, it brings up the back muscles (trapezius).

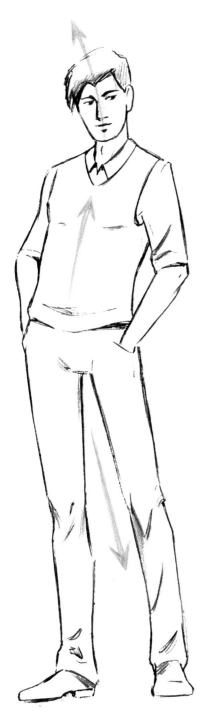

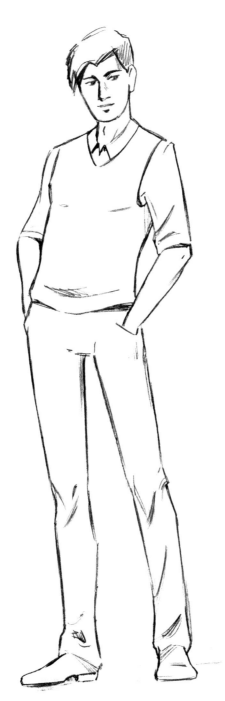

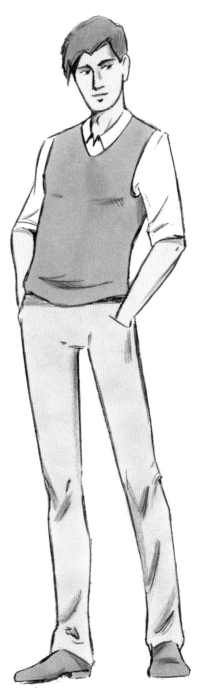

Finished Rough
You can break down the opposing forces even further into three directions.

The "Clean Up" Stage
Some of the details of the original construction are omitted as well. For example, the line of the chest has only been partially included in the finished pencil drawing. It's enough to just suggest it.

Color Finish
Slightly muted colors allow the viewer to notice dynamics of the figure.

Back View

Now we're going to apply these principles to the entire figure in the back view. Once more, we see how a slight shift in the posture, created by opposing forces, is enough to produce a stylish and appealing pose.

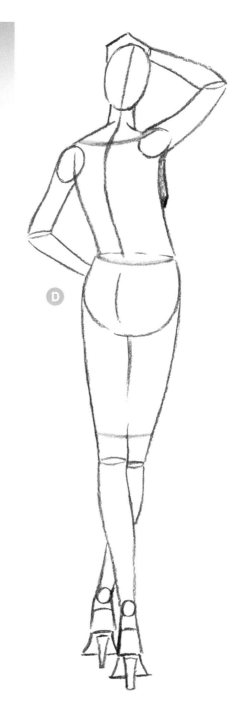

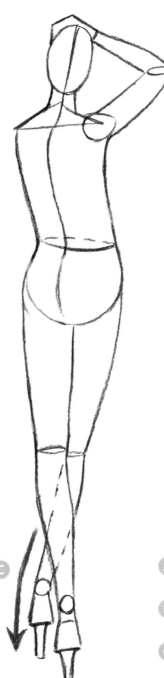

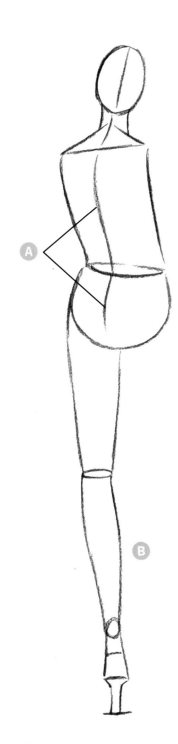

The spine is already hinting at the existence of opposing forces in this pose.

At the outset of the pose, choose which leg will be nearest to the viewer.

The far leg bends at the ankle, to keep the stem of the shoe vertical.

The lines of the clothing

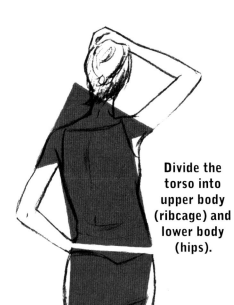

Divide the torso into upper body (ribcage) and lower body (hips).

POSE POINT

Although the degree of the opposing angles is small, the effect is significant because each angle travels a long distance.

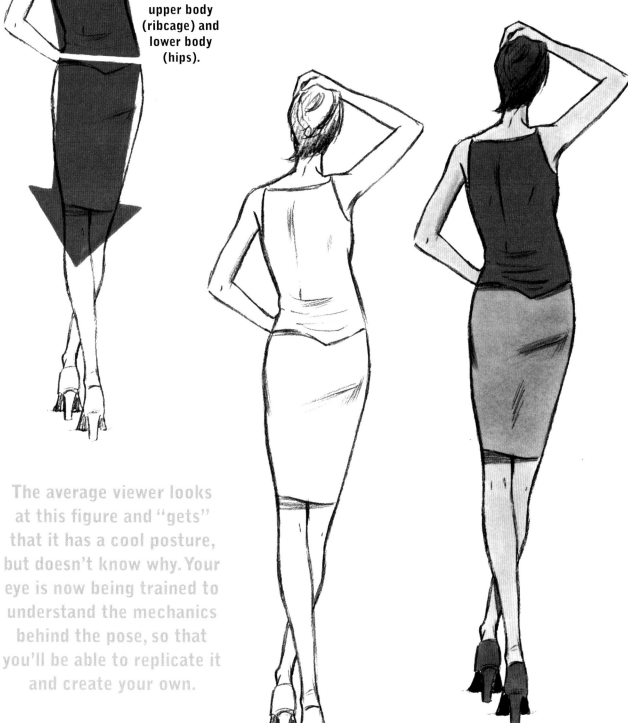

The average viewer looks at this figure and "gets" that it has a cool posture, but doesn't know why. Your eye is now being trained to understand the mechanics behind the pose, so that you'll be able to replicate it and create your own.

Finished Drawing with Color Concept

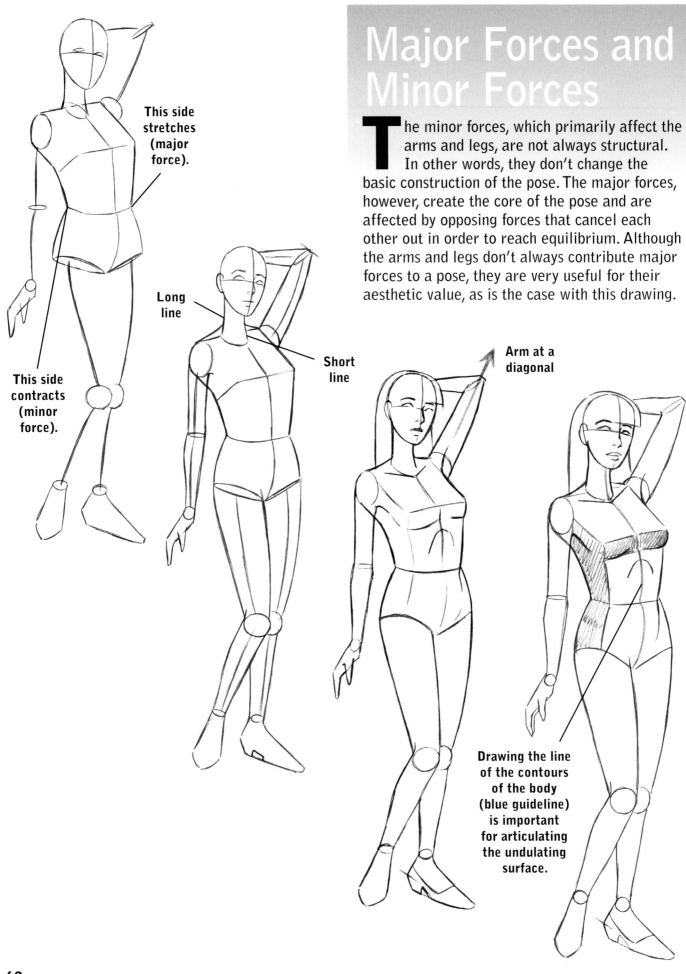

Major Forces and Minor Forces

The minor forces, which primarily affect the arms and legs, are not always structural. In other words, they don't change the basic construction of the pose. The major forces, however, create the core of the pose and are affected by opposing forces that cancel each other out in order to reach equilibrium. Although the arms and legs don't always contribute major forces to a pose, they are very useful for their aesthetic value, as is the case with this drawing.

This side stretches (major force).

This side contracts (minor force).

Long line

Short line

Arm at a diagonal

Drawing the line of the contours of the body (blue guideline) is important for articulating the undulating surface.

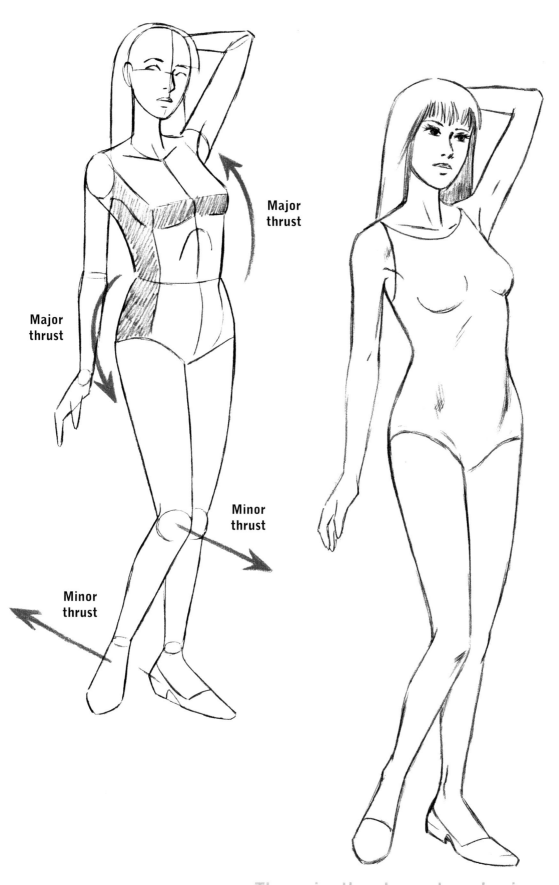

Major thrust

Major thrust

Minor thrust

Minor thrust

The major thrusts create a pleasing, overall pose or posture, while the minor thrusts contribute additional aesthetics.

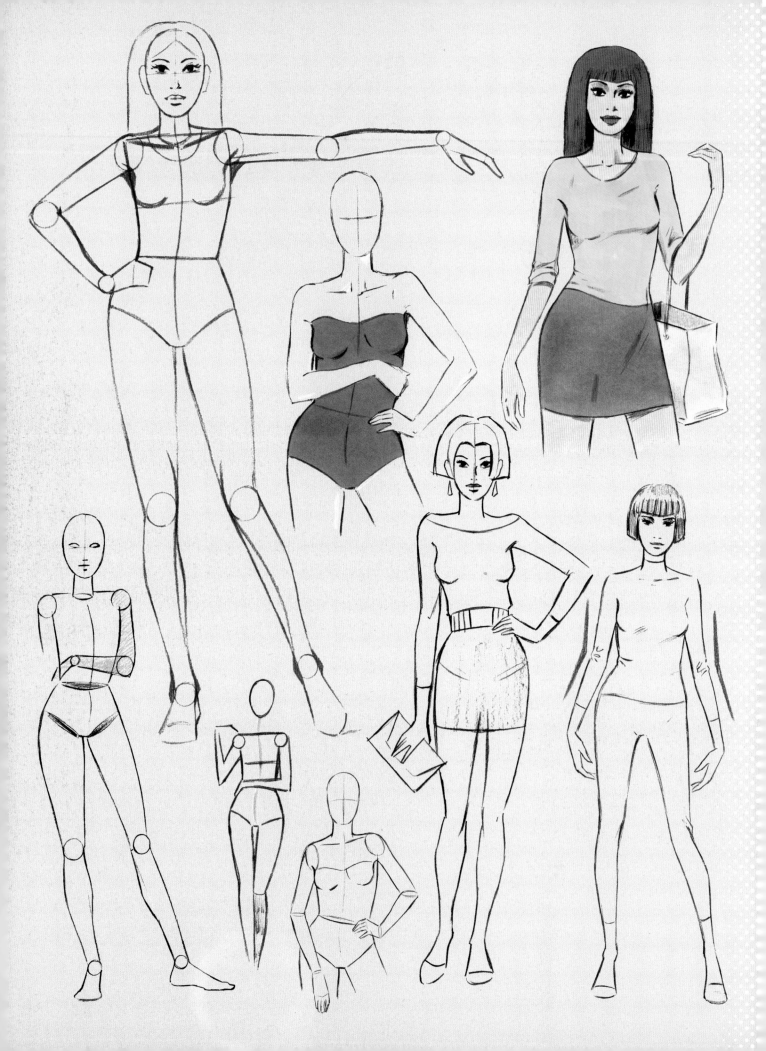

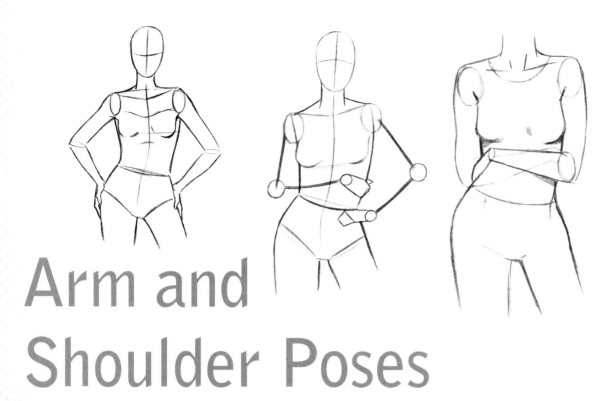

Arm and Shoulder Poses

Now that we've established a solid framework for drawing poses, let's dive into the really fun stuff. You can create endless variations of poses using combinations of arm and leg positions. And here's the great part: changing the position of the arms or legs does not necessarily mean that you have to rearrange the core pose, as we will soon see.

Shoulder Movement

A small tilt of the shoulders can enhance many gestures. Even a slight lift of a shoulder can add style to a pose. Finally, a well positioned shoulder, or shoulders, can transform a pose that would otherwise appear nondescript.

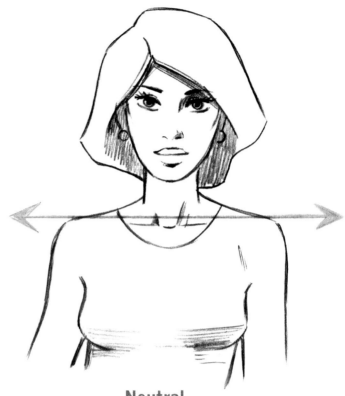

Neutral
Collarbone is horizontal.

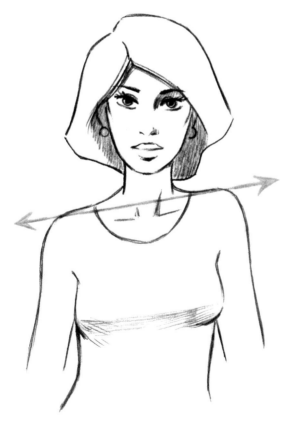

Left Shoulder Down
When drawn on a diagonal, the collarbones maintain a straight line.

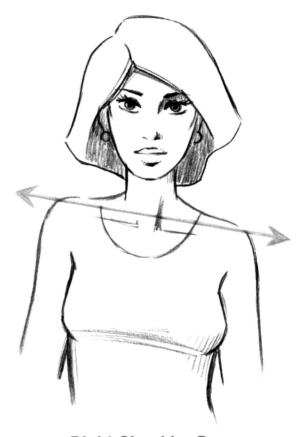

Right Shoulder Down
Can you feel it? Creating an uneven shoulder position adds style to the pose.

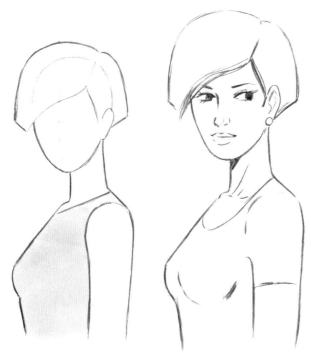

POSE POINT

When aspiring artists think about doing something interesting with the position of the shoulders, they generally think about raising or lowering them. Now it's also time to consider another possibility: shifting them forward or back.

Shoulders Back

By pulling the shoulders back, the torso becomes prominent and the back is hidden. It's a confident look.

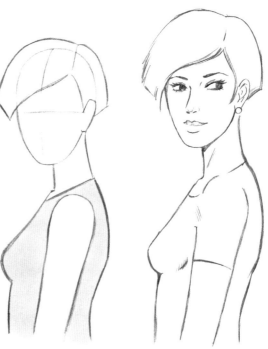

Neutral Shoulders (Centered)

In the centered position, there is equal mass in front of and in back of the shoulder. The side of the torso faces the viewer. This is a natural-looking pose.

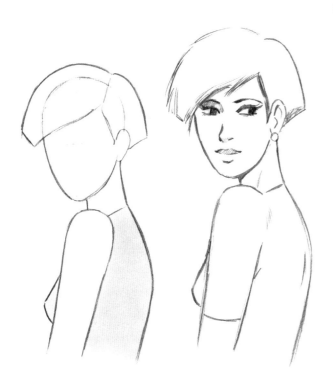

Shoulders Forward

In this position, the shoulder is not only forward but raised. More of the back is seen in this pose. It creates an attitude.

Drawing from a Basic Construction

We'll start with a basic construction of the figure, in a medium shot, to draw a number of popular arm poses. Rather than drawing each arm in a vacuum, let's position each arm in relation to the other, which makes for a stronger pose.

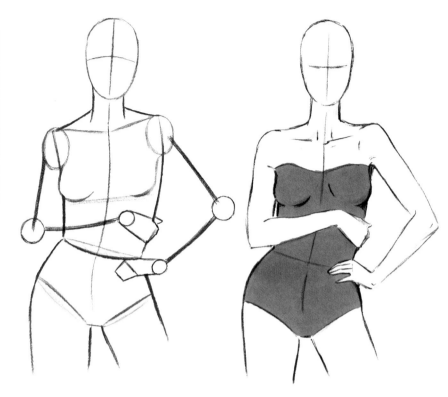

Basic Construction
The blue area is the basic construction. It's going to be our constant. The gray pencil lines represent the variable.

Arm Pose
The viewer only notices the arms, but a well-drawn torso remains the core of the pose.

Variations

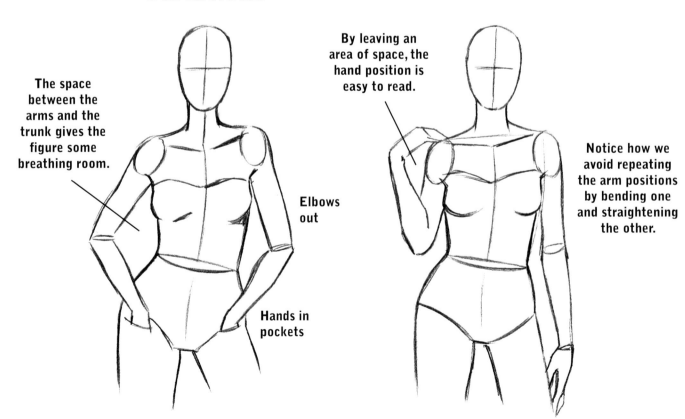

The space between the arms and the trunk gives the figure some breathing room.

Elbows out

Hands in pockets

By leaving an area of space, the hand position is easy to read.

Notice how we avoid repeating the arm positions by bending one and straightening the other.

68

Part of the shoulder shows, because it has greater size than the forearm.

The arms touch, creating a right angle.

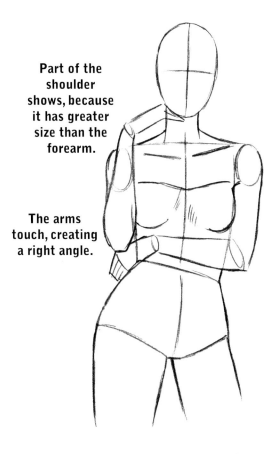

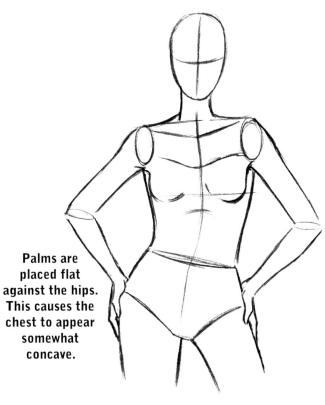

Palms are placed flat against the hips. This causes the chest to appear somewhat concave.

This symmetrical pose gets its appeal from the sharp look of the elbows.

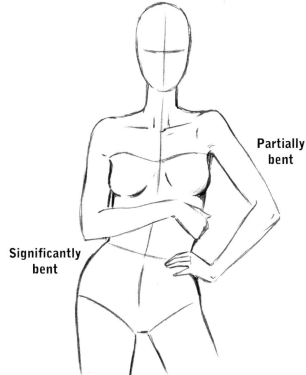

Partially bent

Significantly bent

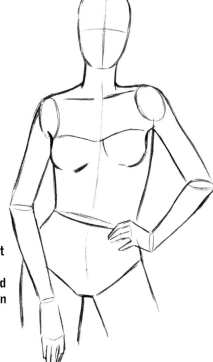

A slightly bent arm, on the thigh, is a good way to show an arm at rest.

The arms are bent at different angles, so as not to repeat themselves. Generally, the greater the bend, the higher up the elbow appears on the body.

Not every stance requires a purposeful pose. It's also important to be able to show the relaxed figures doing nothing in particular.

Counterpoise

The arms mirror each other, which is called *counterpoise*. It's a good tool for relating one arm to the other. It's also pleasing to the eye, which intuitively senses the balance.

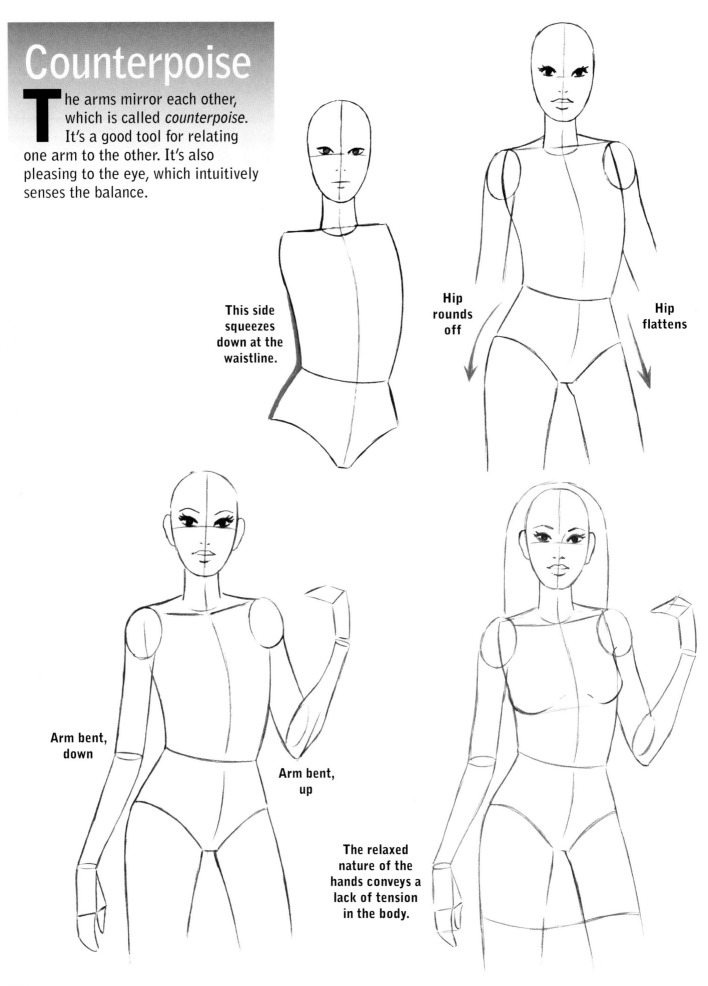

This side squeezes down at the waistline.

Hip rounds off

Hip flattens

Arm bent, down

Arm bent, up

The relaxed nature of the hands conveys a lack of tension in the body.

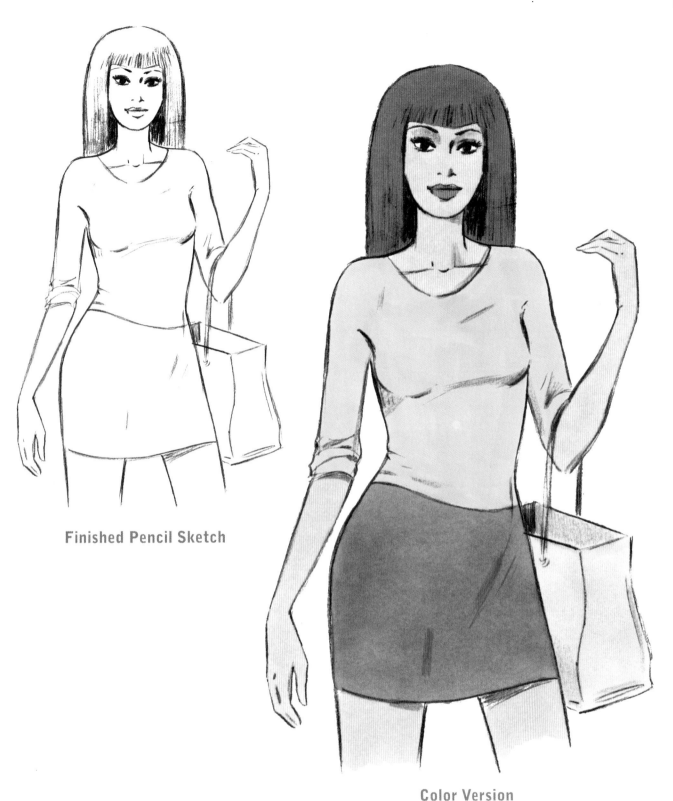

Finished Pencil Sketch

Color Version

POSE POINT

Not all counterpoised poses look as relaxed and spontaneous as this one. For example, a figure with hands on hips is in counterpoise, but not necessarily relaxed. The pose could represent impatience.

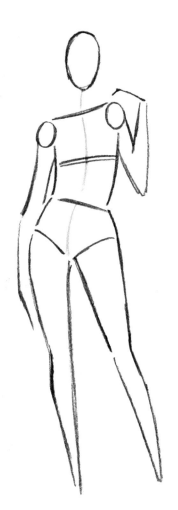

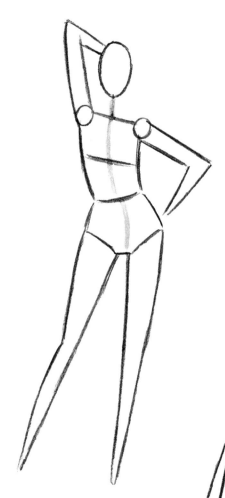

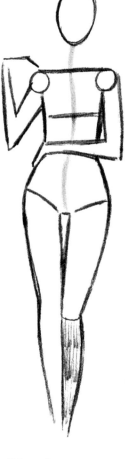

The body shifts to the left at the hips.

The Center Line does a dynamic shift to the right to accentuate the dramatic arm positions.

The Center Line is fairly straight, reflecting the geometric arm positions.

Full Figure Arm-Based Poses

On this page, I have prominently drawn the Center Line in blue down the middle of the torso and hips, which I did to highlight the principle that the body continues to show dynamics, even when you're drawing poses that highlight the arms.

The Center Line stretches, following the lead of the reaching arm.

Crossed Arms

Ah yes, I feel your pain. If you've had trouble drawing this arm position, then I've got good news for you. It's actually not a difficult pose—really. But you have to go in order. If you simply draw spontaneously, it can be a beast. Let's try it.

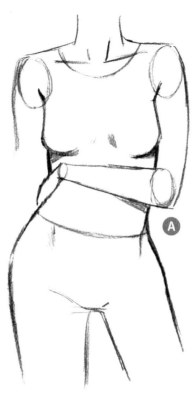

A Instead of drawing both arms at the same time, completely draw the top arm—the one that will take the dominant position in the final drawing.

B Draw the second arm under the first arm.

C Draw the entire second arm, even the part that will ultimately be erased (blue lines).

D The elbows dip. The arms cross in the center of the torso.

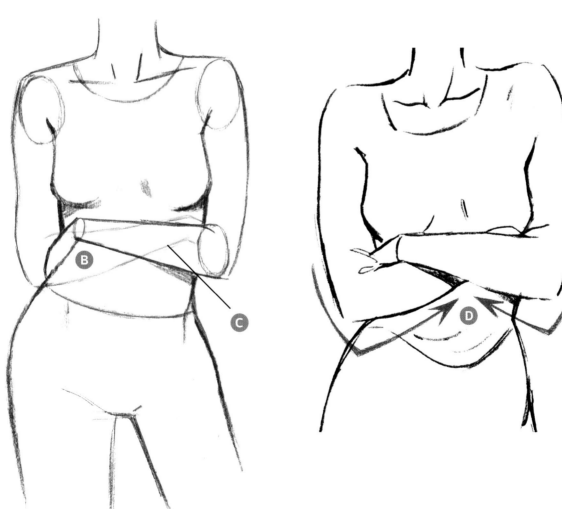

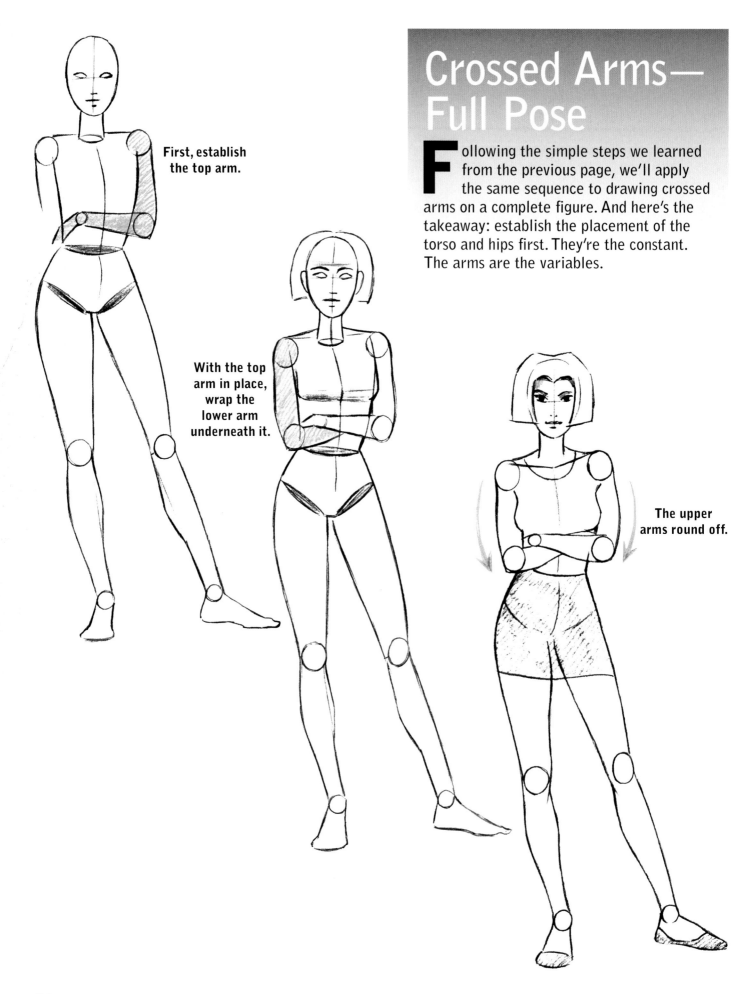

First, establish the top arm.

Crossed Arms— Full Pose

Following the simple steps we learned from the previous page, we'll apply the same sequence to drawing crossed arms on a complete figure. And here's the takeaway: establish the placement of the torso and hips first. They're the constant. The arms are the variables.

With the top arm in place, wrap the lower arm underneath it.

The upper arms round off.

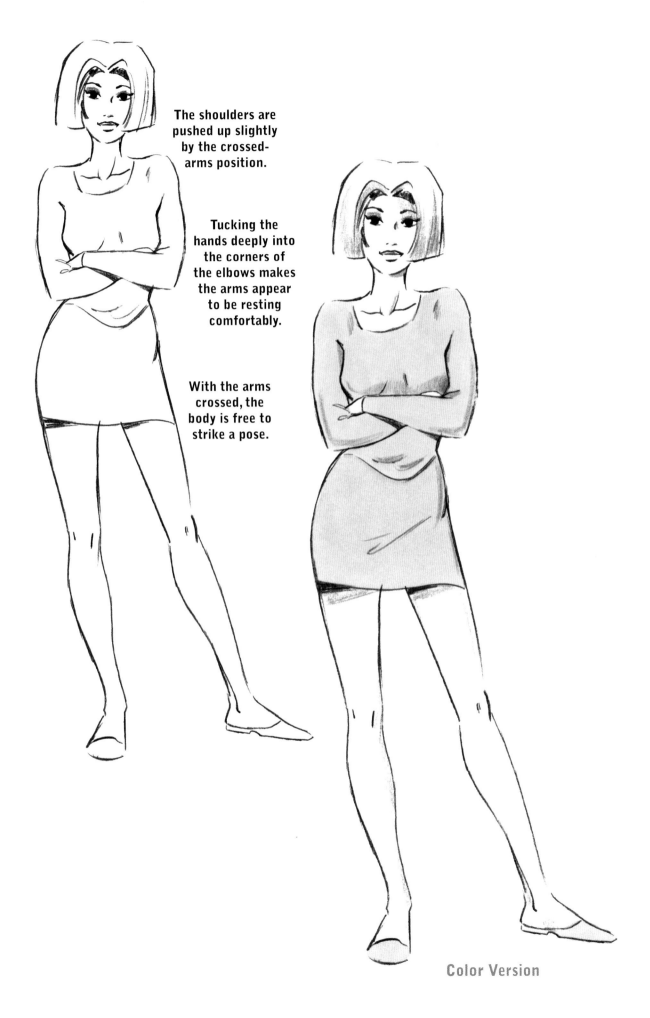

The shoulders are pushed up slightly by the crossed-arms position.

Tucking the hands deeply into the corners of the elbows makes the arms appear to be resting comfortably.

With the arms crossed, the body is free to strike a pose.

Color Version

Problem Solved!

What do you do with arms that just hang at the sides? How do you make them look natural? The solution is simple: add a slight bend to the elbows. Instantly, the pose loses its stiffness.

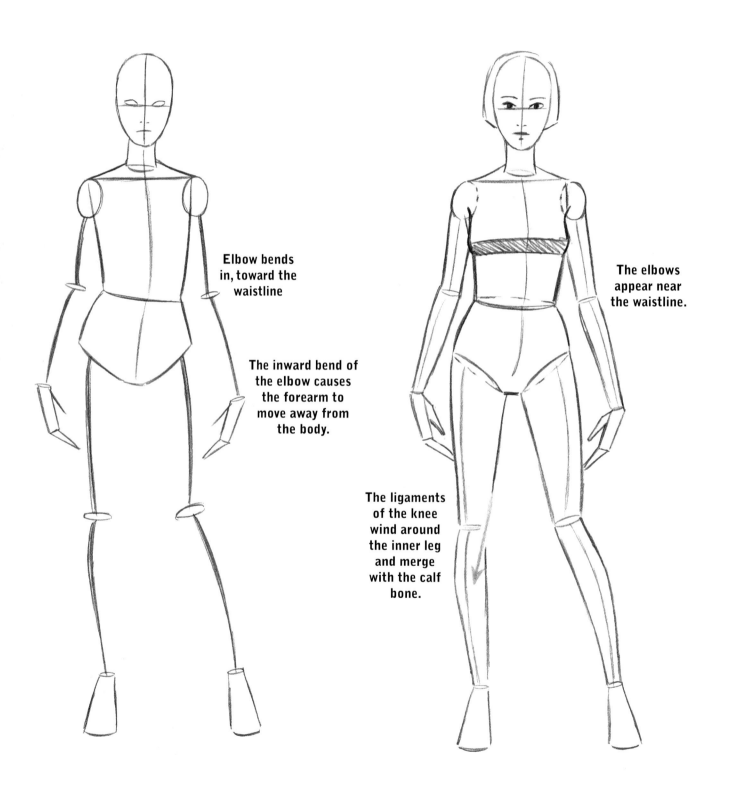

Elbow bends in, toward the waistline

The inward bend of the elbow causes the forearm to move away from the body.

The elbows appear near the waistline.

The ligaments of the knee wind around the inner leg and merge with the calf bone.

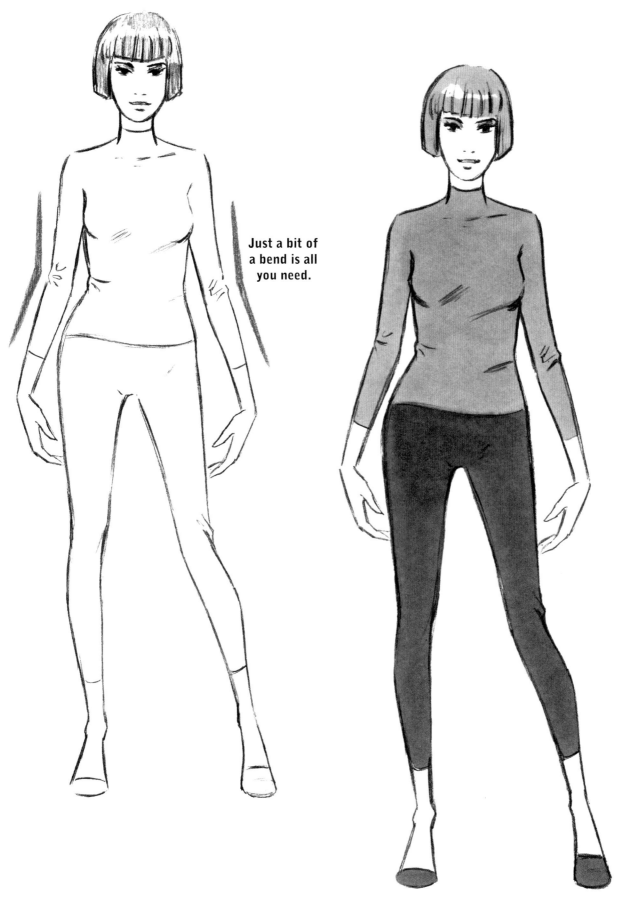

Just a bit of
a bend is all
you need.

**Final Pencil Drawing
with Gray Tones**

77

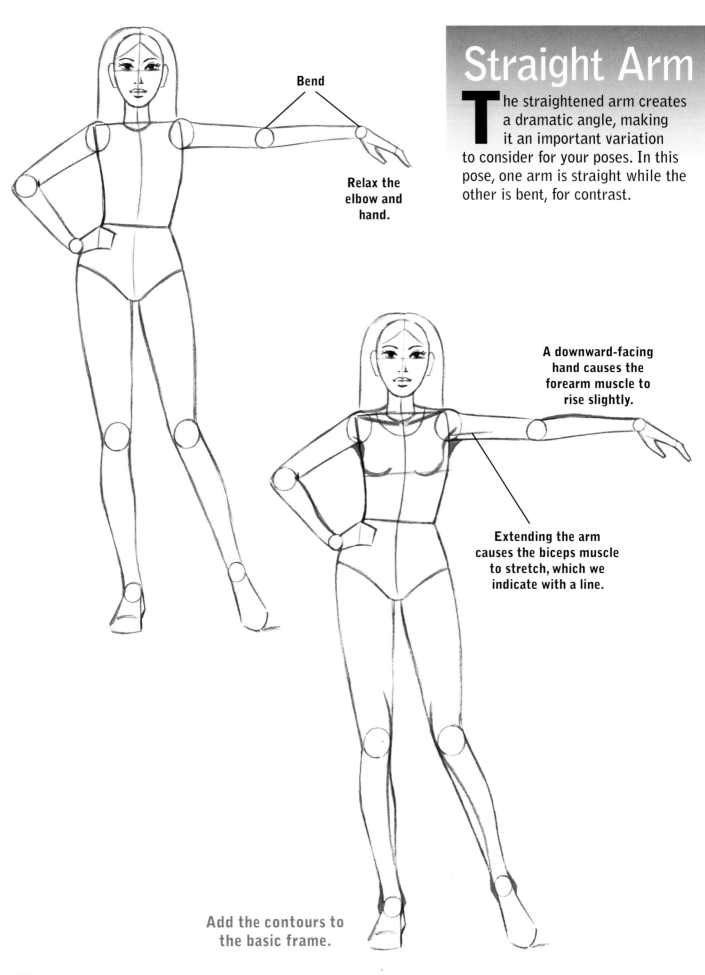

Bend

Relax the elbow and hand.

The straightened arm creates a dramatic angle, making it an important variation to consider for your poses. In this pose, one arm is straight while the other is bent, for contrast.

A downward-facing hand causes the forearm muscle to rise slightly.

Extending the arm causes the biceps muscle to stretch, which we indicate with a line.

Add the contours to the basic frame.

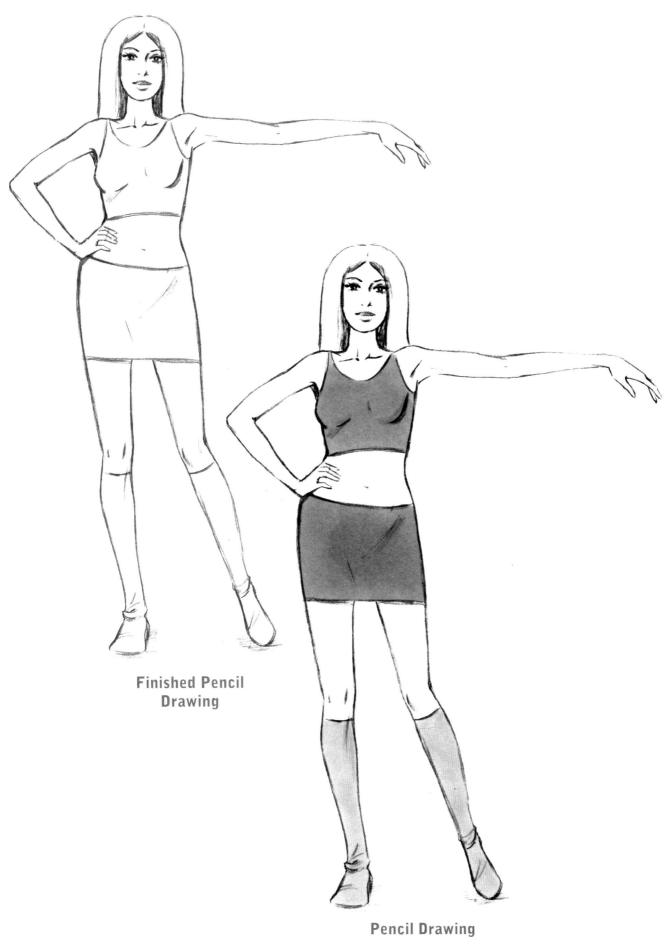

Finished Pencil Drawing

Pencil Drawing with Gray Tones

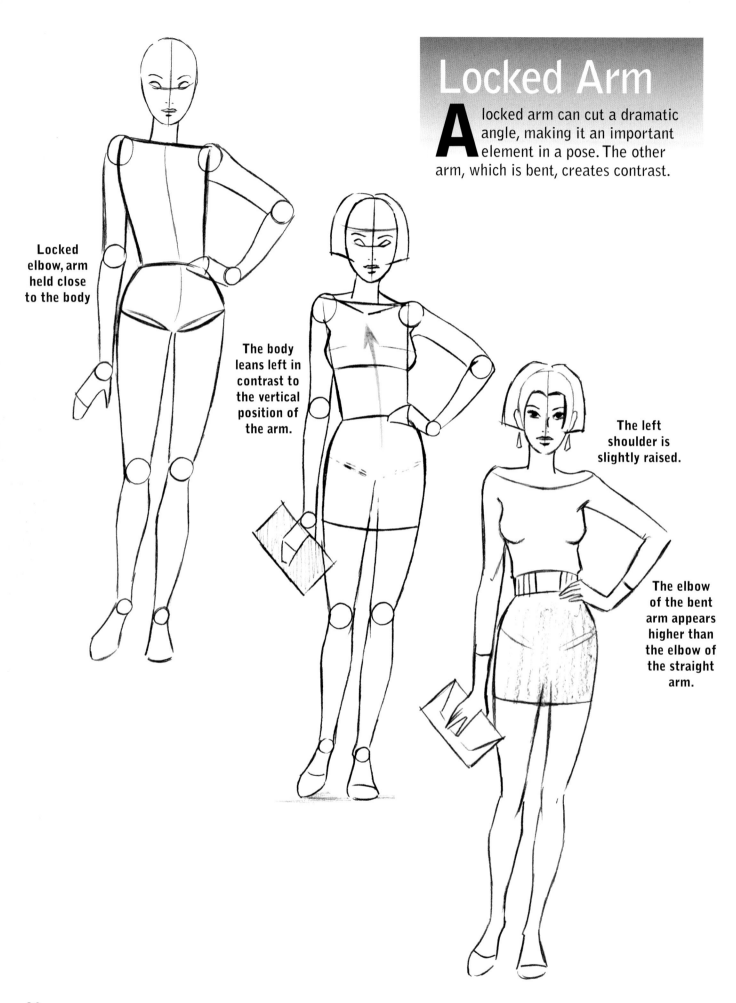

Locked Arm

A locked arm can cut a dramatic angle, making it an important element in a pose. The other arm, which is bent, creates contrast.

Locked elbow, arm held close to the body

The body leans left in contrast to the vertical position of the arm.

The left shoulder is slightly raised.

The elbow of the bent arm appears higher than the elbow of the straight arm.

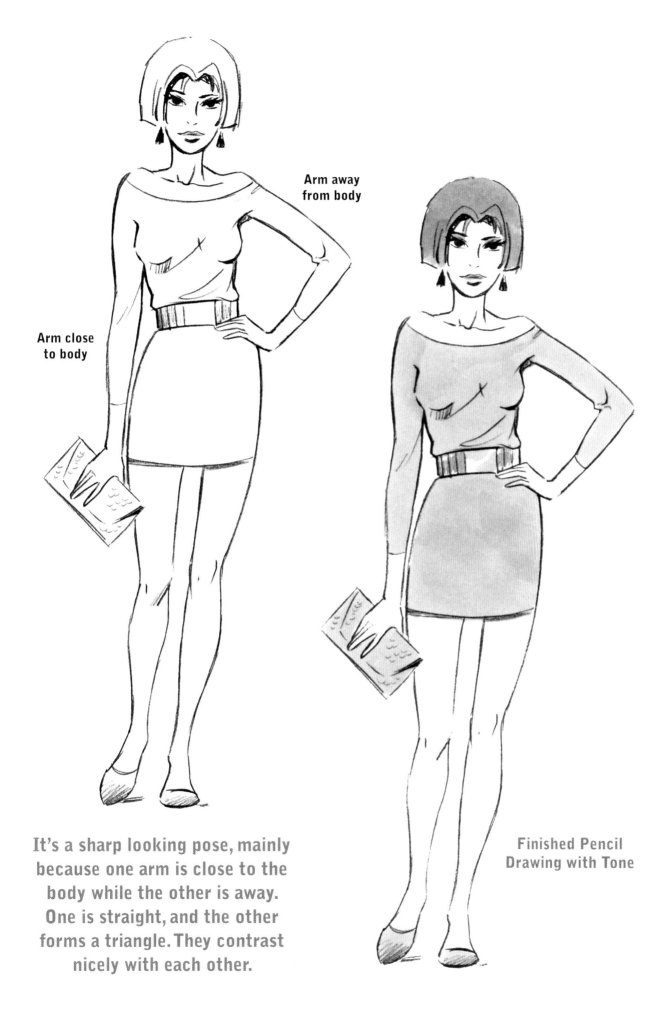

Arm away from body

Arm close to body

It's a sharp looking pose, mainly because one arm is close to the body while the other is away. One is straight, and the other forms a triangle. They contrast nicely with each other.

Finished Pencil Drawing with Tone

Shoulders Raised

When someone leans back against a bench, the weight of the body applies pressure to the arms causing the shoulders to compensate by rising. External forces, like the bench, also create interesting poses. When the body compensates in response to external forces, the pose becomes more appealing. As artists, we use external forces as tools to create interesting poses. So here's the takeaway: don't ignore these forces; incorporate them!

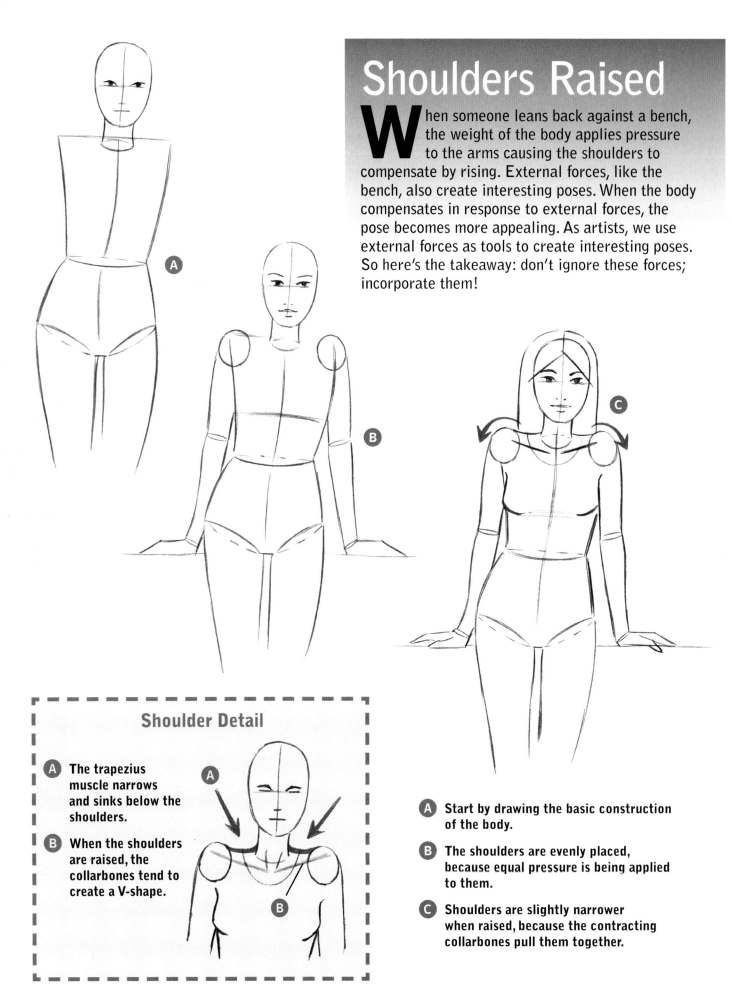

Shoulder Detail

A The trapezius muscle narrows and sinks below the shoulders.

B When the shoulders are raised, the collarbones tend to create a V-shape.

A Start by drawing the basic construction of the body.

B The shoulders are evenly placed, because equal pressure is being applied to them.

C Shoulders are slightly narrower when raised, because the contracting collarbones pull them together.

82

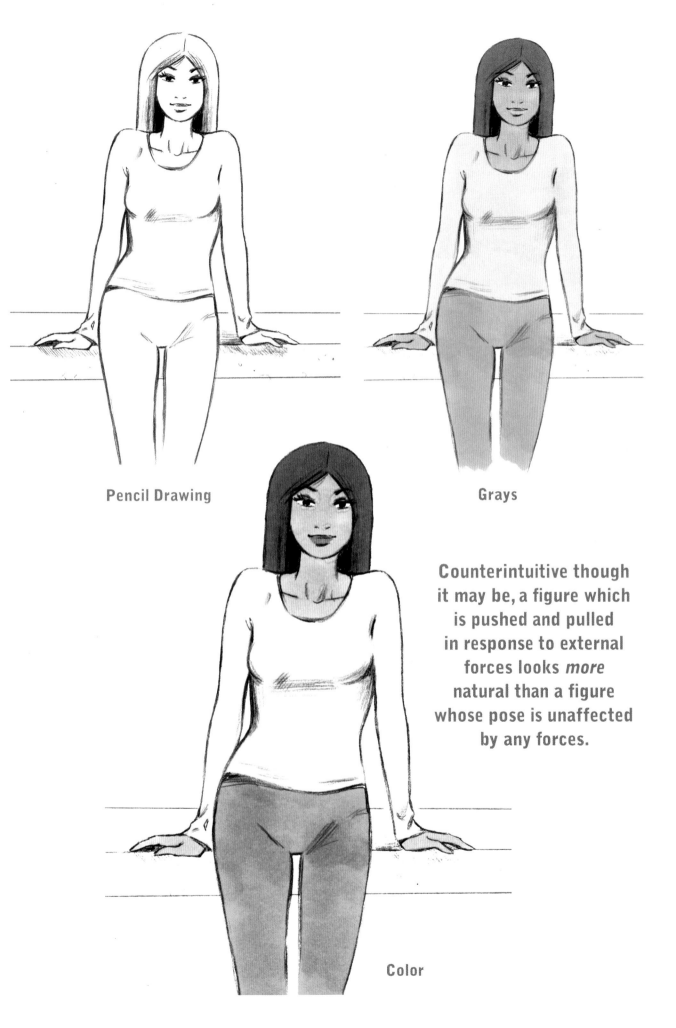

Pencil Drawing

Grays

Counterintuitive though it may be, a figure which is pushed and pulled in response to external forces looks *more* natural than a figure whose pose is unaffected by any forces.

Color

Shoulders Pulled Back

Here's a popular pose—hands on the hips, elbows back. What may not seem obvious is that the shoulders are essential for breathing life into the pose. If the shoulders were left in a neutral position, the torso wouldn't stretch, and as a result, you wouldn't get liveliness from the pose. Let's put energy into the pose by utilizing the shoulders dynamically.

The torso pushes forward.

Big curve for the back

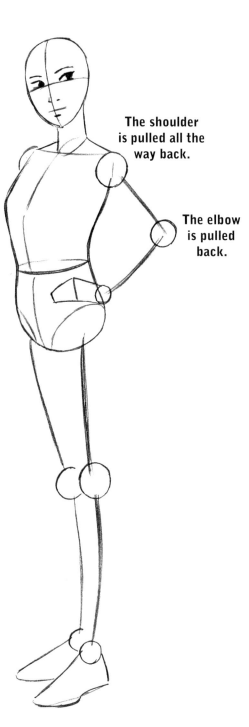

The shoulder is pulled all the way back.

The elbow is pulled back.

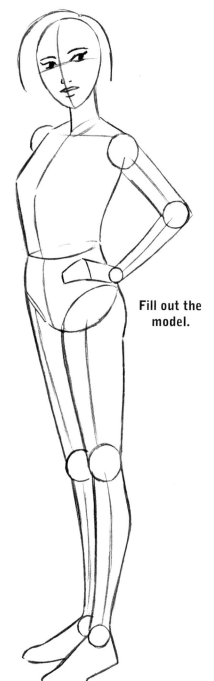

Fill out the model.

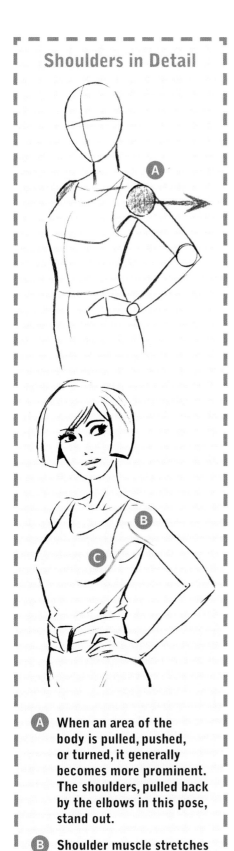

Shoulders in Detail

Ⓐ When an area of the body is pulled, pushed, or turned, it generally becomes more prominent. The shoulders, pulled back by the elbows in this pose, stand out.

Ⓑ Shoulder muscle stretches

Ⓒ Chest muscle stretches

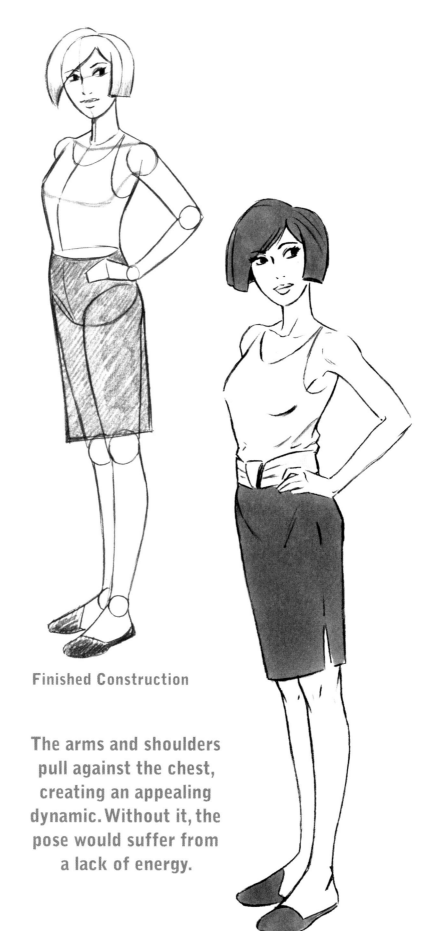

Finished Construction

The arms and shoulders pull against the chest, creating an appealing dynamic. Without it, the pose would suffer from a lack of energy.

Final Pose

85

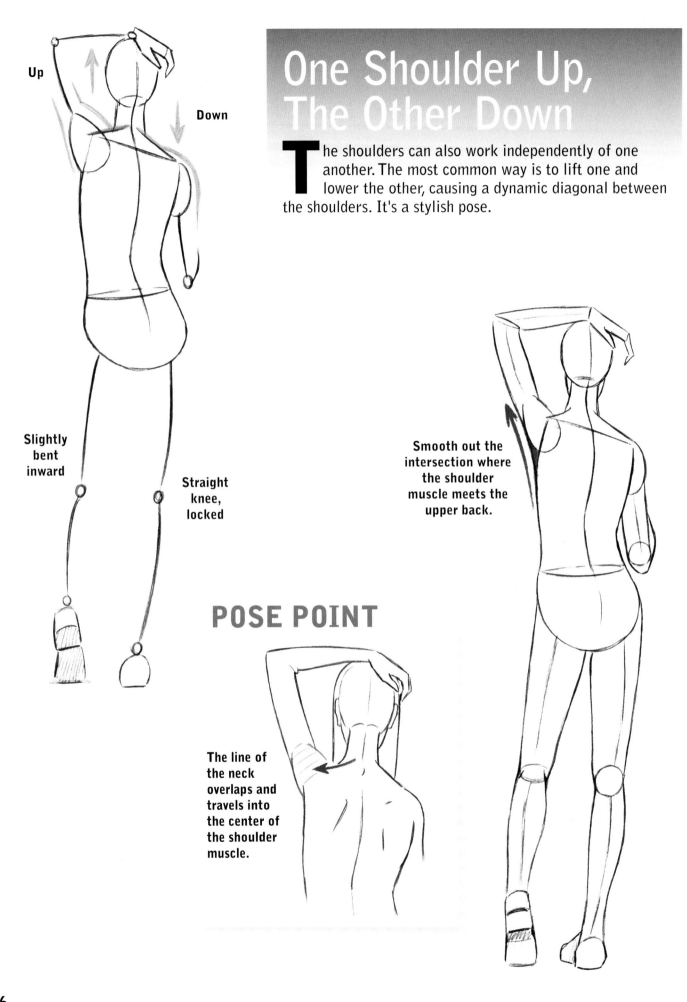

Up

Down

One Shoulder Up, The Other Down

The shoulders can also work independently of one another. The most common way is to lift one and lower the other, causing a dynamic diagonal between the shoulders. It's a stylish pose.

Slightly bent inward

Straight knee, locked

Smooth out the intersection where the shoulder muscle meets the upper back.

POSE POINT

The line of the neck overlaps and travels into the center of the shoulder muscle.

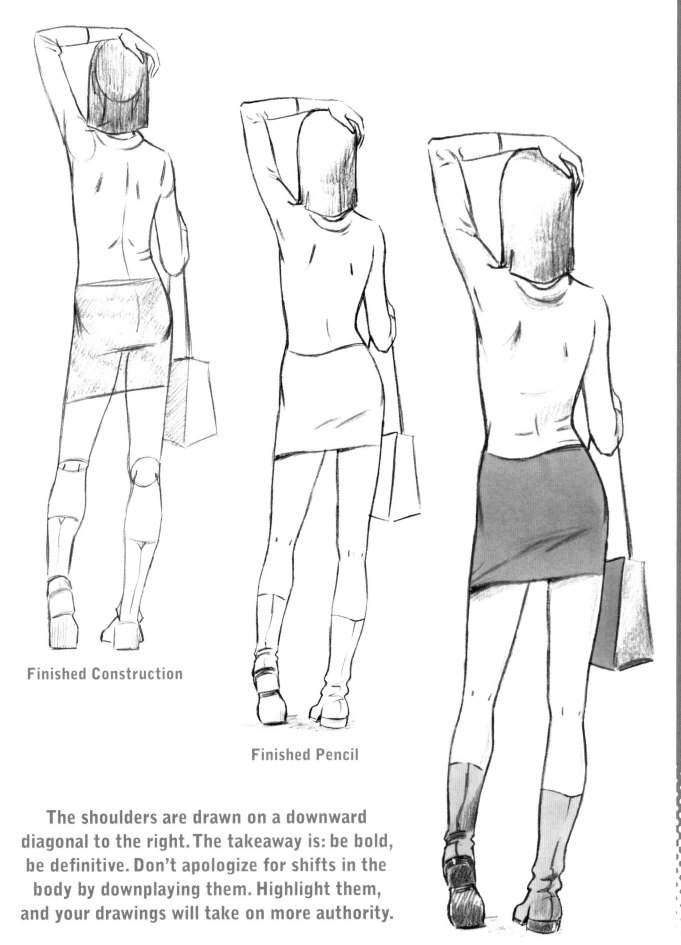

Finished Construction

Finished Pencil

Pencil, with Tone

The shoulders are drawn on a downward diagonal to the right. The takeaway is: be bold, be definitive. Don't apologize for shifts in the body by downplaying them. Highlight them, and your drawings will take on more authority.

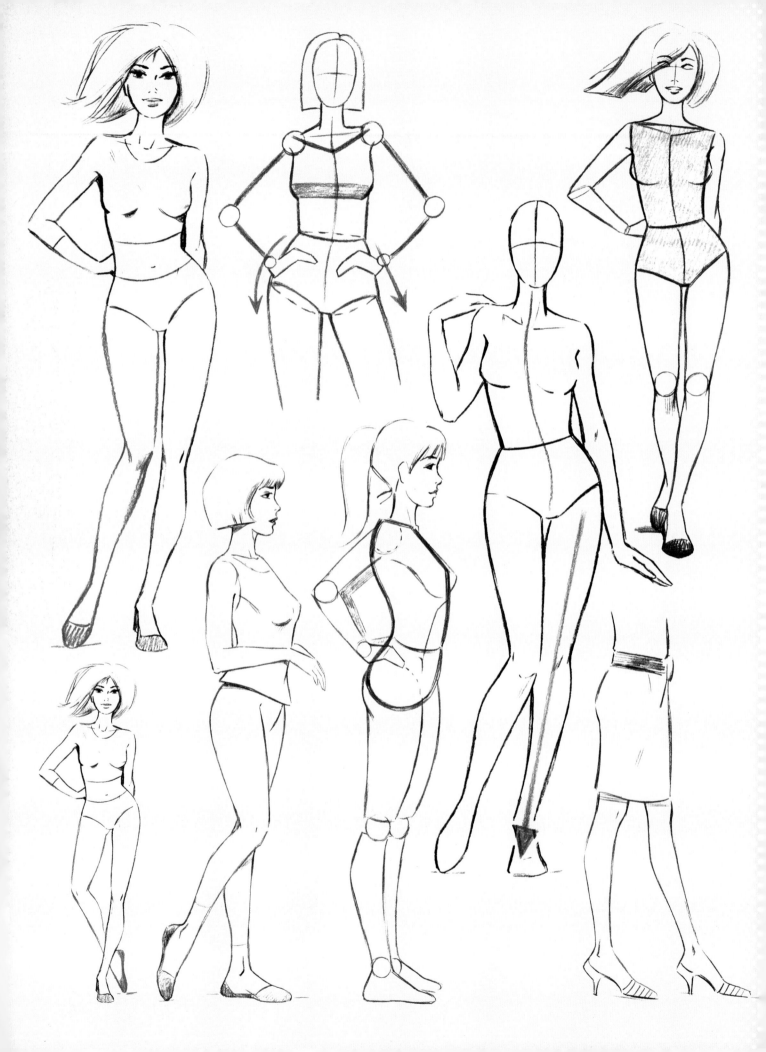

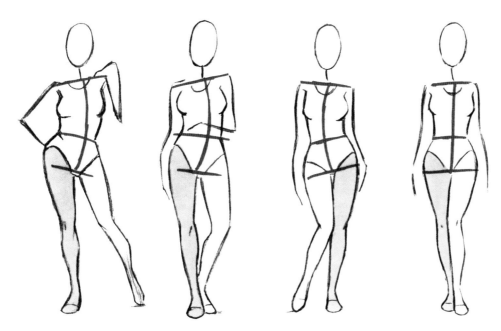

Leg Poses

There are many ways to pose the arms symmetrically: hands at the sides, both hands on hips, arms crossed, one arm up and one arm down, both hands on top of the head, etc. But there are only a few ways to pose the legs symmetrically: together, apart, or crossed. There are many more leg poses, but they are off-center. These off-center poses can be highly effective and dramatic. The leg is a big section of the body; when it moves, the body usually compensates to conserve equilibrium. As we progress through this chapter, we'll discover inventive ways to use the legs to create compelling poses.

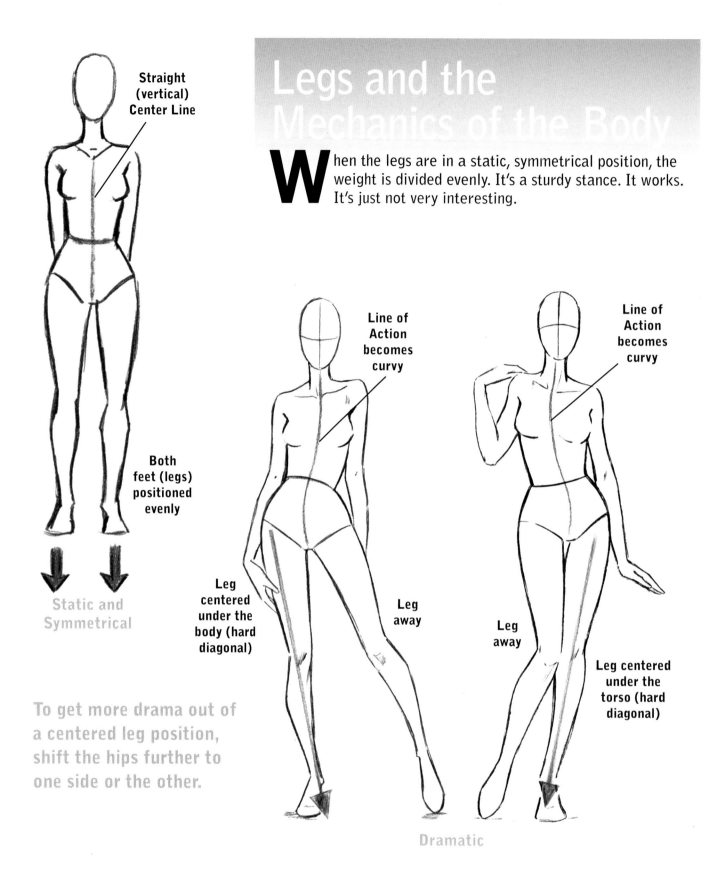

Legs and the Mechanics of the Body

When the legs are in a static, symmetrical position, the weight is divided evenly. It's a sturdy stance. It works. It's just not very interesting.

Straight (vertical) Center Line

Both feet (legs) positioned evenly

Static and Symmetrical

To get more drama out of a centered leg position, shift the hips further to one side or the other.

Line of Action becomes curvy

Leg centered under the body (hard diagonal)

Leg away

Dramatic

Line of Action becomes curvy

Leg away

Leg centered under the torso (hard diagonal)

POSE POINT

When one leg is directly under the body, it frees up the other leg.

90

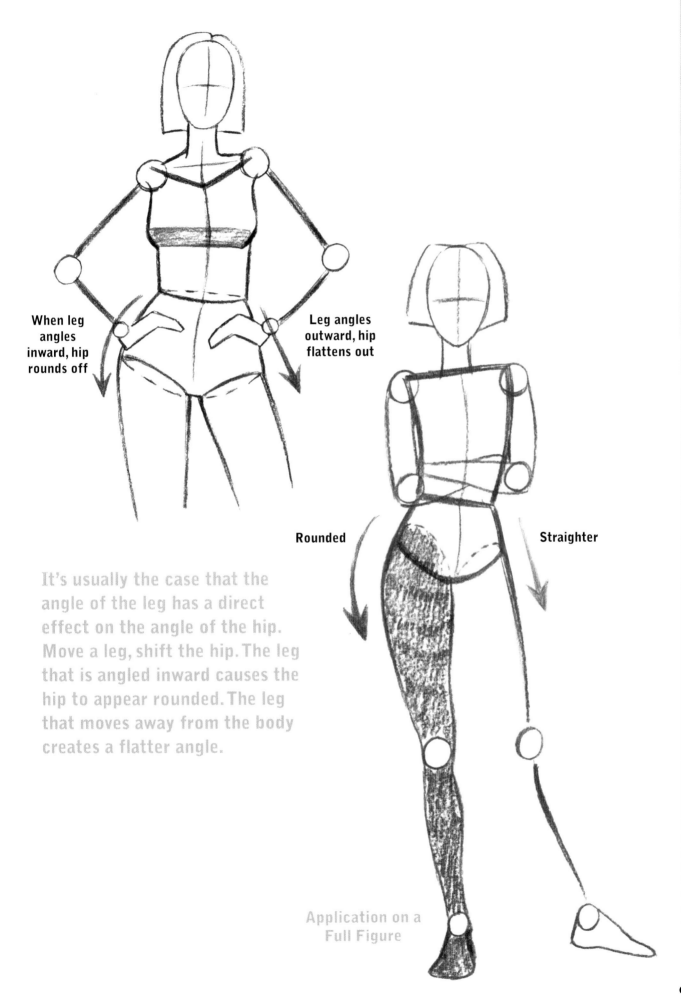

When leg angles inward, hip rounds off

Leg angles outward, hip flattens out

Rounded

Straighter

It's usually the case that the angle of the leg has a direct effect on the angle of the hip. Move a leg, shift the hip. The leg that is angled inward causes the hip to appear rounded. The leg that moves away from the body creates a flatter angle.

Application on a Full Figure

The Walk

Another way to suggest action is, naturally, to draw your figure performing an action. However, there's nothing inherently interesting about someone doing a simple task. You have to do something creative with it. Maybe it's a different way to perform the action, or the body language, or style. For example, walking offers many variations in style and is well suited for aesthetics. Runway models take advantage of this all the time. In the front view, the walk has a lot of energy and a fashionable flair.

In the walk, the legs cross. But it's where they cross that is most important: primarily at the feet, ankles, or lower calves.

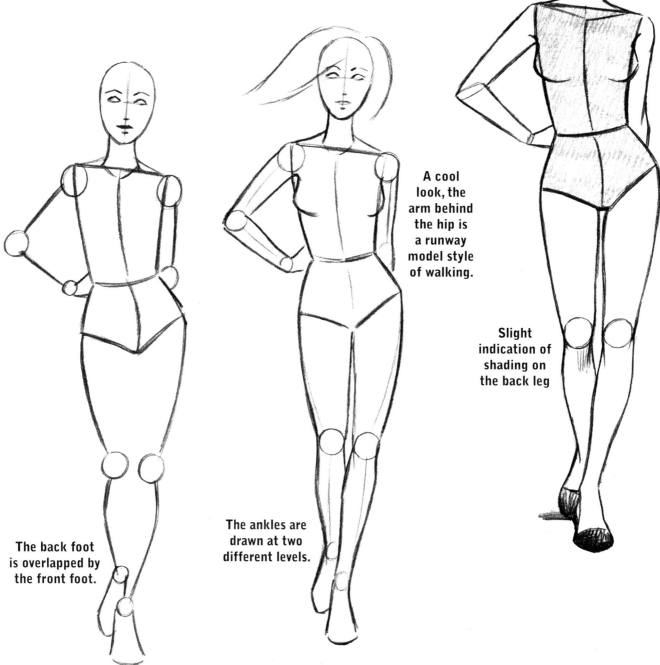

A cool look, the arm behind the hip is a runway model style of walking.

Slight indication of shading on the back leg

The ankles are drawn at two different levels.

The back foot is overlapped by the front foot.

92

Variations on a Pose

How do you create a new pose? Not always from scratch. Before you begin to create an entirely new pose, see if you can reinvent the original one. This page will show you how a pose can be significantly altered simply by changing the position of one leg.

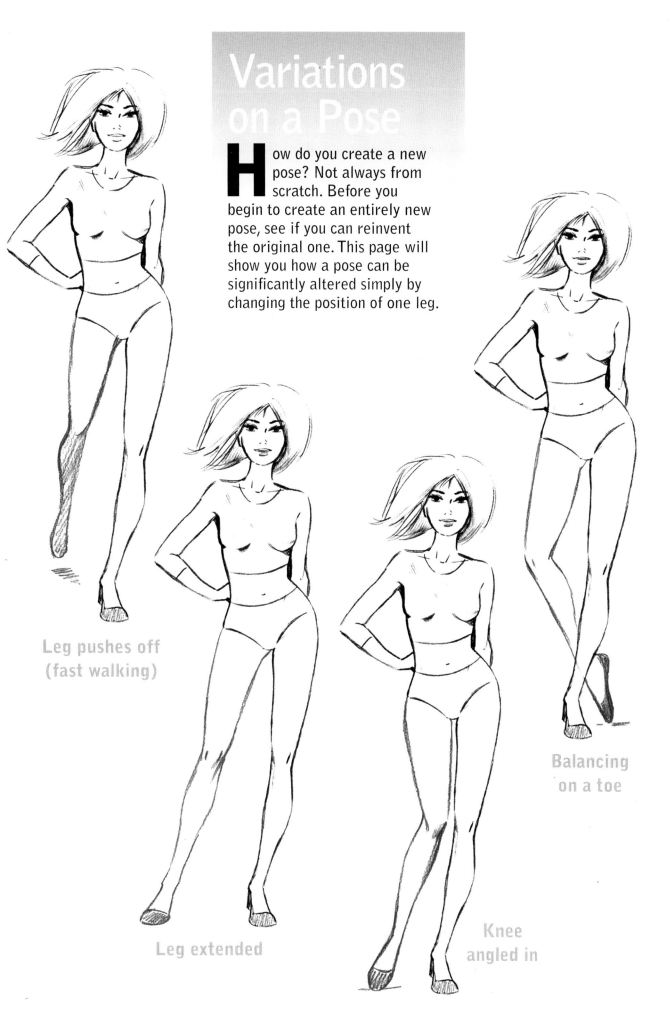

Leg pushes off (fast walking)

Leg extended

Knee angled in

Balancing on a toe

93

Turning the Feet

Here's a technique you can use to add an accent to your drawings. Start with the feet at shoulder-length apart. That's a pretty standard stance, but not one that really stands out. Now, draw the same stance, but turn the feet so that the toes point slightly inward. As a result of this small adjustment, the pose becomes stylish and playful.

Add some flow to the torso, so the pose won't appear stiff.

The feet are shoulder-length apart, which is a comfortable way for people to stand.

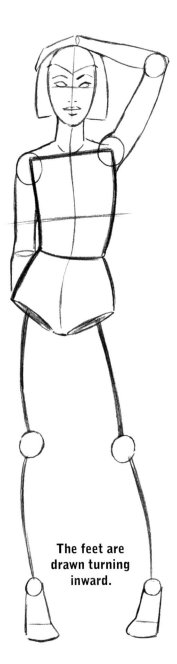

The feet are drawn turning inward.

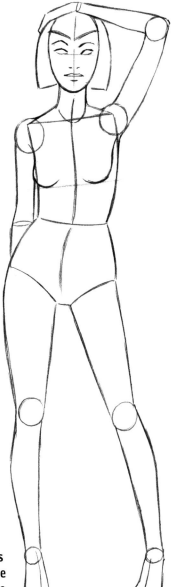

For an extra accent, I've lifted the heels up, adding more emphasis to the balls of the feet.

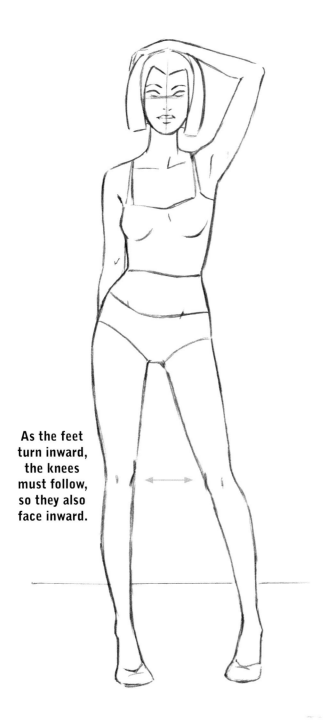

As the feet turn inward, the knees must follow, so they also face inward.

POSE POINT

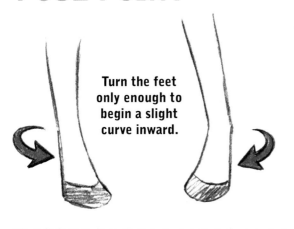

Turn the feet only enough to begin a slight curve inward.

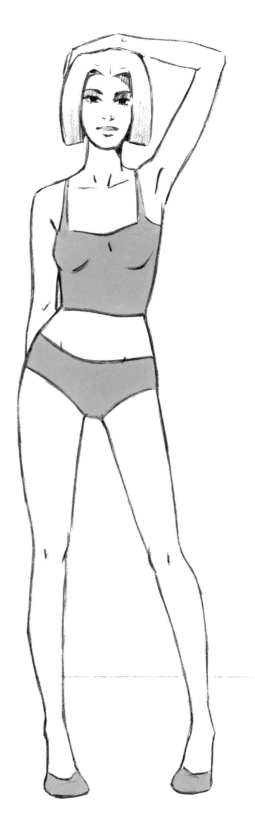

Though the accent of this pose—the turn of the feet—takes place at the bottom of the figure, its effect is felt throughout the pose.

95

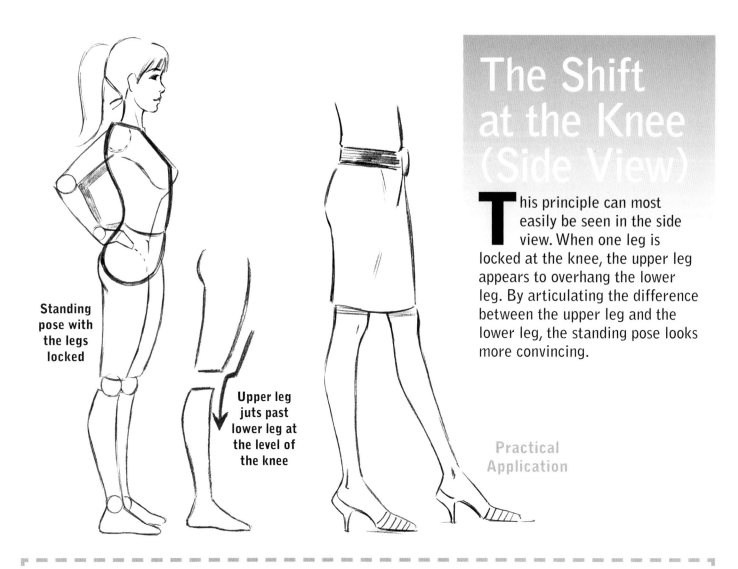

The Shift at the Knee (Side View)

This principle can most easily be seen in the side view. When one leg is locked at the knee, the upper leg appears to overhang the lower leg. By articulating the difference between the upper leg and the lower leg, the standing pose looks more convincing.

Standing pose with the legs locked

Upper leg juts past lower leg at the level of the knee

Practical Application

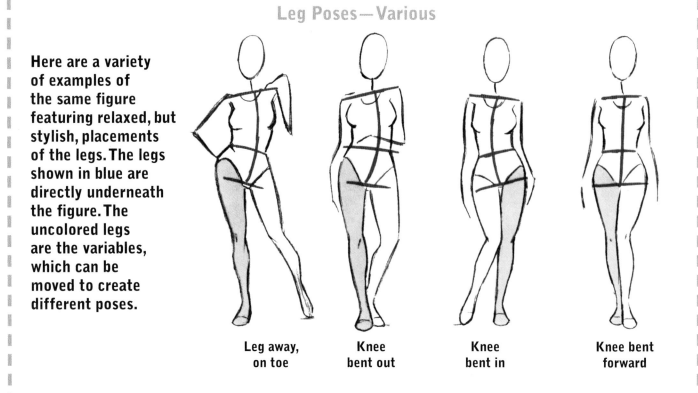

Leg Poses—Various

Here are a variety of examples of the same figure featuring relaxed, but stylish, placements of the legs. The legs shown in blue are directly underneath the figure. The uncolored legs are the variables, which can be moved to create different poses.

Leg away, on toe

Knee bent out

Knee bent in

Knee bent forward

Bending the Leg

It can get redundant if you draw the legs side by side. It's often more effective if you were to draw one knee out in front of the other. If both knees were drawn together, the far knee would appear hidden behind the near knee, and the result would be a flat look.

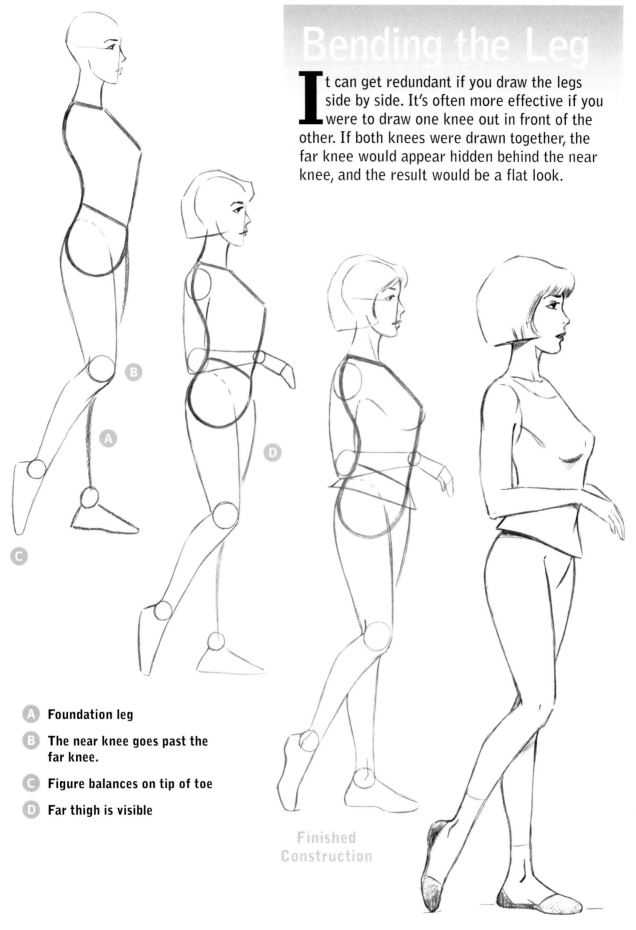

Ⓐ Foundation leg

Ⓑ The near knee goes past the far knee.

Ⓒ Figure balances on tip of toe

Ⓓ Far thigh is visible

Finished Construction

Finished Pencil Sketch

97

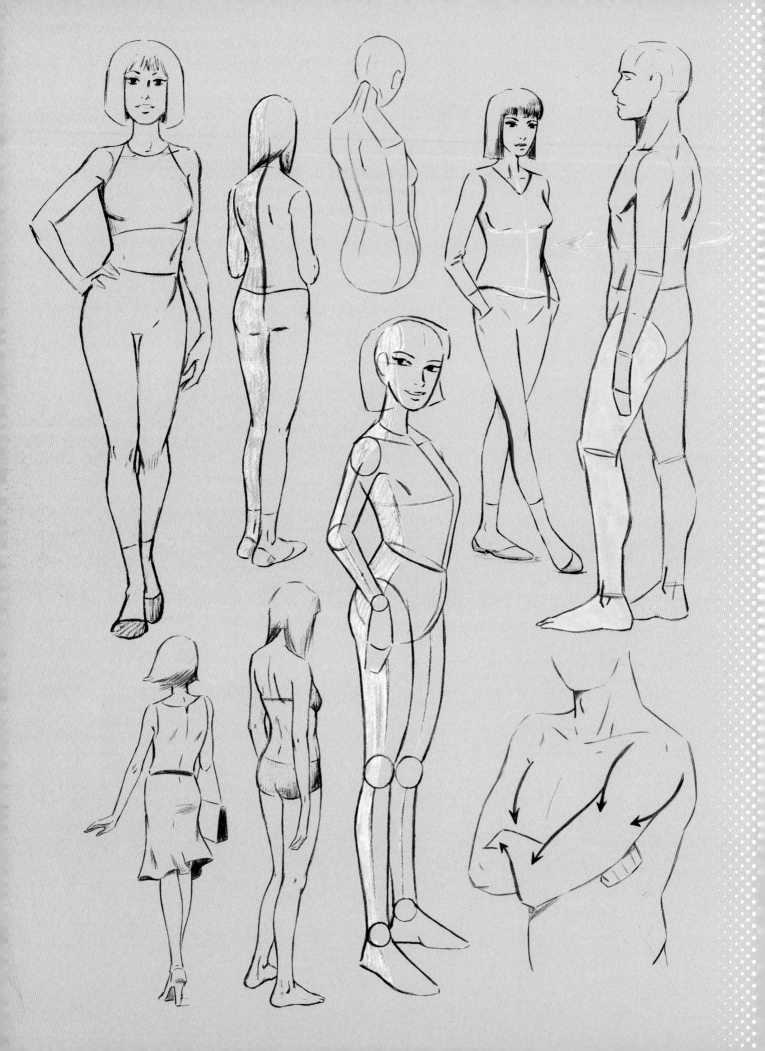

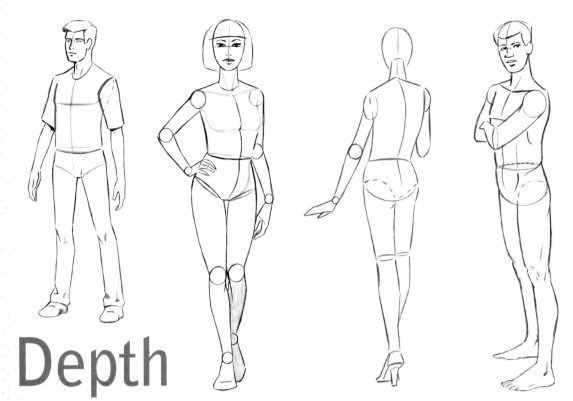

Depth

In order to draw the figure, you have to create the look of three dimensions.

We can draw left to right. We can draw up and down. But it's that third dimension, going forward and back, which we must find a way to imply. Some poses are naturally flat looking, but we don't have to be constrained to that. There's a lot we can do to create a round look, so that our figures appear more convincing.

Some poses are good at conveying depth, such as the three-quarter view. But others are inherently flat looking. I'll show you how to create a round look, so that your figures will appear to be real and less two-dimensional.

Depth—Side View

This angle creates the flattest view of the figure. But it's a practical pose, so don't discard it just because it seems to lack dimension. We're going to learn various ways to enhance it. The first way makes no adjustment to the line drawing whatsoever, but simply applies shadow strategically. Shadow makes an object appear to be solid, because only a solid object can block, or partially block, a light source, thereby casting a shadow.

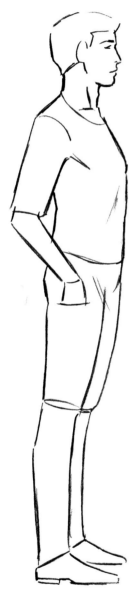

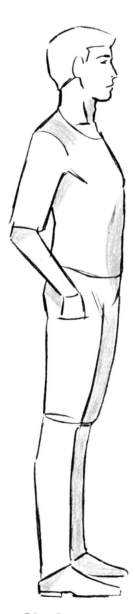

Flat
This is a line drawing without any consideration to depth. It's a nicely drawn figure, but it has an oddly empty look.

Applying Shadow
The shadow areas are indicated in blue. Notice in each, something blocks the light, casting a shadow. The green areas hint at a different angle, and therefore depth. For example, the figure is in a side view, yet we can see a touch of his stomach and the top of the shoulders. Tone can also be added here.

Figure with Shadow
Avoid a heavy-handed approach. A few suggestions of shadow, strategically applied, round out the look.

Shifting the Center Line— Side View

In a typical side view, the Center Line (the red guideline) is drawn along the edge of the body. This is a flat look. To add depth, we have to begin to move away from a strict side view, and to indicate this, we'll use the Center Line. By shifting the Center Line slightly back from the edge, it has the effect of showing a sliver of the far side of the figure, which suggests depth. In addition, a turn of the head, from a side view to a three-quarter view, also shows depth.

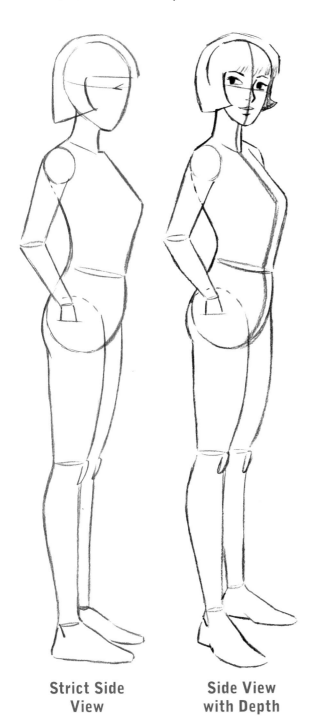

Strict Side View

Side View with Depth

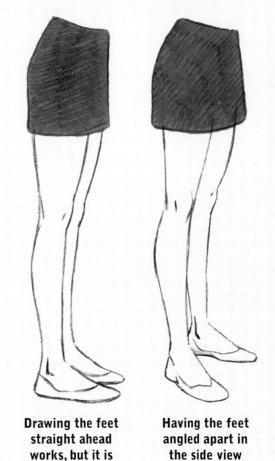

Move Those Feet!

Beginners have the tendency to draw both feet straight ahead in a side view. But that's not how most people stand. They spread their feet slightly outward. This, too, helps to create a look of depth in the side view.

Drawing the feet straight ahead works, but it is a flat look.

Having the feet angled apart in the side view looks natural and adds depth.

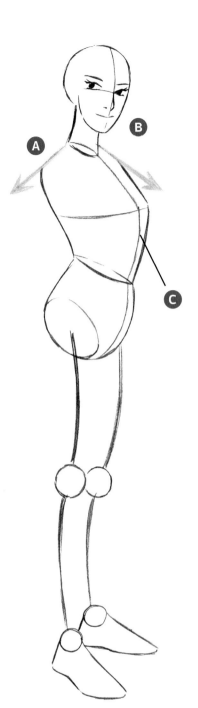

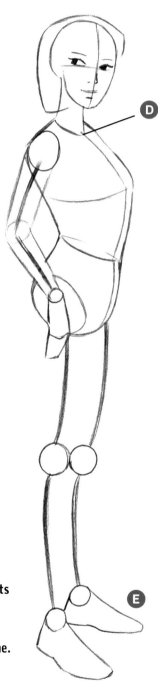

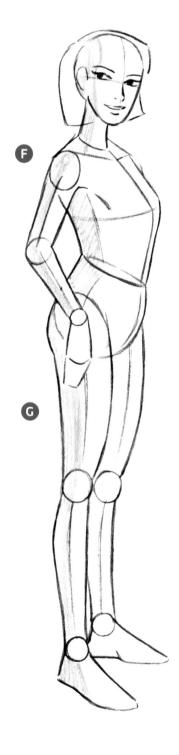

From Construction to Finished Figure

Now that we've got the concept, let's put the principles into action. We'll build the modified side view, starting from the beginning.

(A) The near side slope of the shoulder is the only full shoulder visible in a side view.

(B) Head at a ¾ angle, not profile

(C) Although the figure appears to be in a side view, we draw the Center Line, which represents the center of the body, inside the outline of the figure.

(D) The base of the neck connects to the Center Line.

(E) Feet angle outward

(F) Shoulder pulled back

(G) Add shadow by creating a new plane along the left side of the figure.

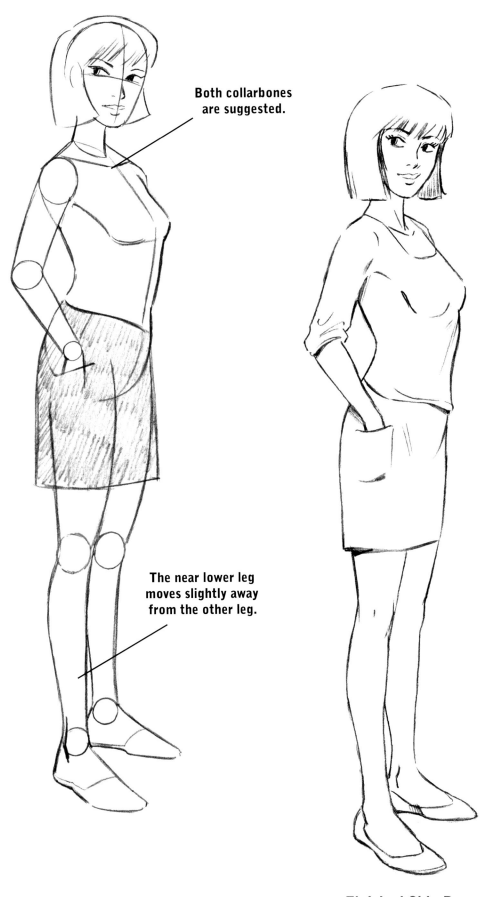

Both collarbones are suggested.

The near lower leg moves slightly away from the other leg.

Finished Side Pose, with Elements of Depth

103

Turning the Torso—Side View

We've seen how we can add depth to a side view by turning the figure slightly toward the viewer. Turning it more than that would look forced. But suppose we still feel the need for more depth? We can achieve it by drawing one leg so that it appears to turn the body at an angle. Although people really do stand this way, the mechanics don't actually cause the leg to pull the torso out of a side view. We are creating an aesthetic with this pose in order to add the look of depth to the side view.

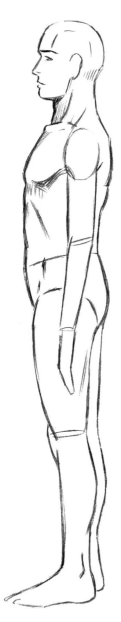

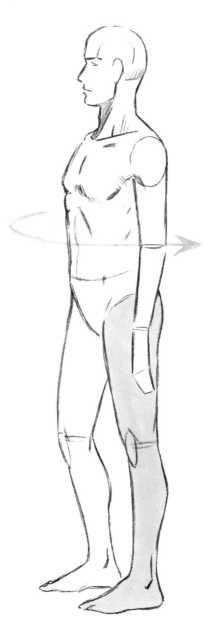

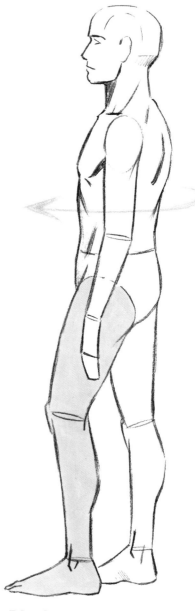

True Side View

When the leg is back, it appears to pull the torso left, which shows the far side of the torso and thereby adds depth to the pose.

Placing the leg forward appears to twist the torso to the right, exposing more of the back and adding depth.

104

Overlap and Depth

The phenomenon of overlap is the way our eye instantly recognizes what is nearer to us and what is farther from us. If a car drives in front of a house, we instantly recognize that the car is closer to us than the house. Depth is sensed as the distance between foreground and background objects. The same holds true for figures, but at a much smaller distance, such as when an arm is in front of a torso.

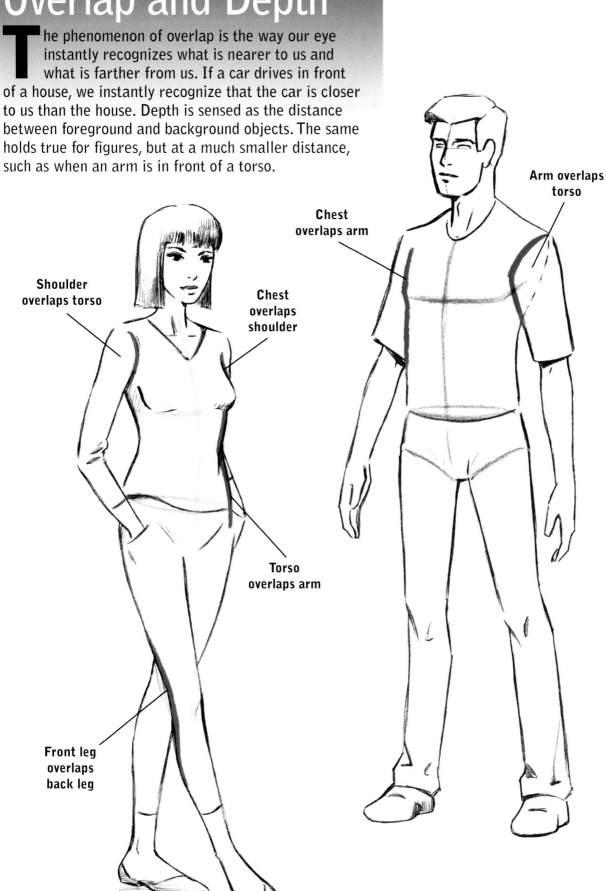

Shoulder overlaps torso

Chest overlaps shoulder

Chest overlaps arm

Arm overlaps torso

Torso overlaps arm

Front leg overlaps back leg

Handling the Details

When drawing a detailed area of a pose, be sure that the lines nearest to you, the viewer, overlap the lines that are further away. These intertwined arms, for example, only work because of the extensive use of overlapping lines.

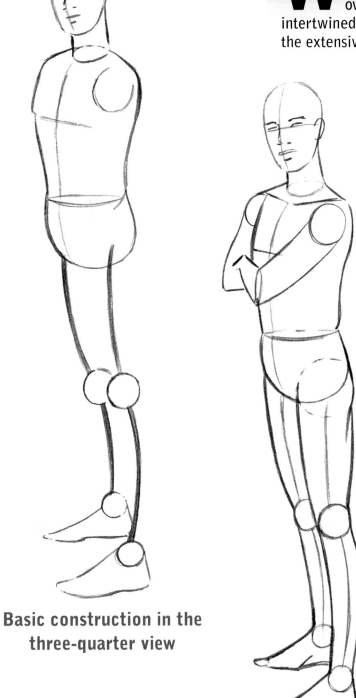

Basic construction in the three-quarter view

Arrive at the basic placement of arms before establishing any overlapping lines

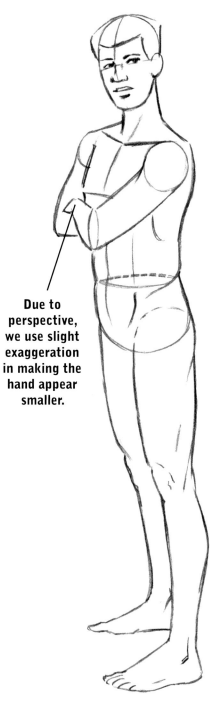

Due to perspective, we use slight exaggeration in making the hand appear smaller.

Finish the rough construction.

POSE POINT

When one line overlaps another line, it usually invades another section of the body. Let's see how that works.

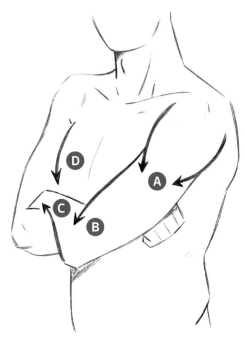

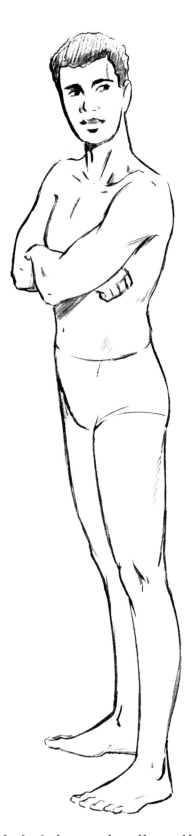

A Line of the shoulder invades upper arm

B Line of upper arm (bicep) invades lower arm.

C Bottom of forearm invades wrist

D Line of chest overlaps the far arm.

In the final sketch, you hardly notice all of the techniques that go into creating the pose. It's not that artists purposely try to hide what they're doing from the audience, like a magician. The point is that when the mechanics of figure drawing are understood and applied, it looks natural.

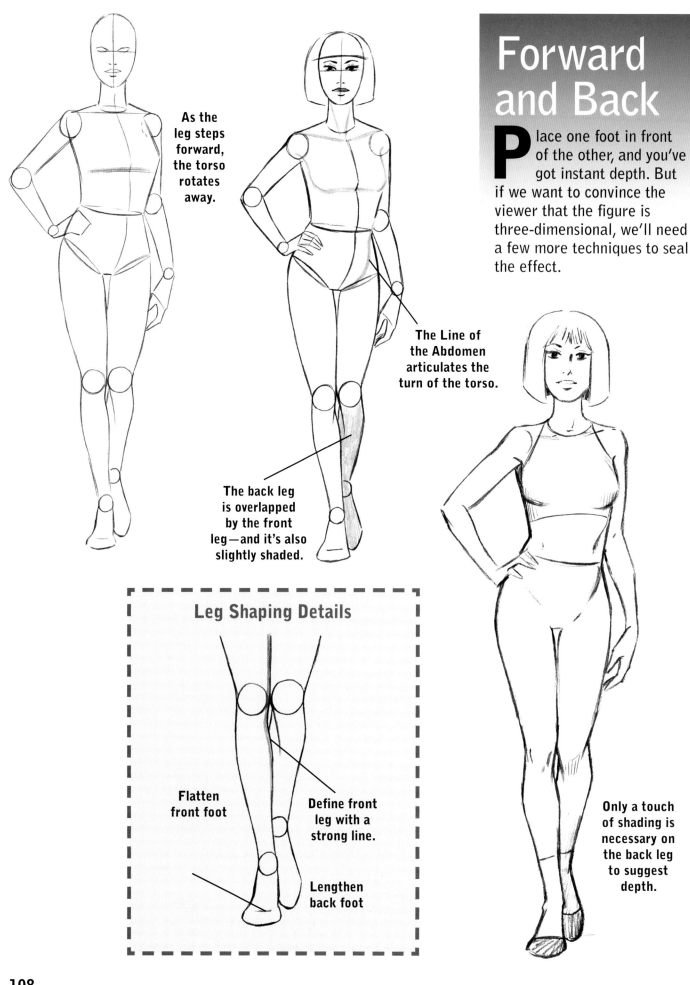

As the leg steps forward, the torso rotates away.

Forward and Back

Place one foot in front of the other, and you've got instant depth. But if we want to convince the viewer that the figure is three-dimensional, we'll need a few more techniques to seal the effect.

The Line of the Abdomen articulates the turn of the torso.

The back leg is overlapped by the front leg—and it's also slightly shaded.

Leg Shaping Details

Flatten front foot

Define front leg with a strong line.

Lengthen back foot

Only a touch of shading is necessary on the back leg to suggest depth.

108

The Back—Easy Solutions

The most obvious, and also the easiest, way to suggest depth in the back view is by turning the figure slightly, so that it no longer faces the viewer squarely. Even a small angle is enough to get rid of a flat look. As you turn the figure, the Center Line (which travels the same path as the spine), reveals curves that aren't apparent in a full view of the back. This, too, creates a lifelike look.

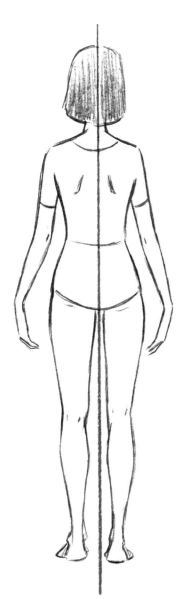

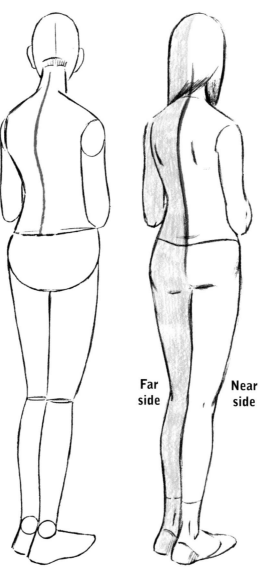

Far side

Near side

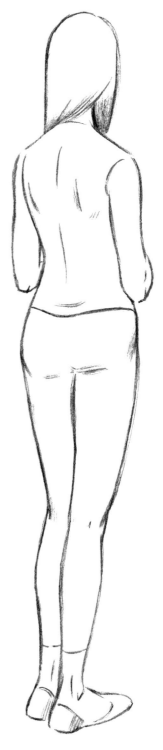

Full View of the Back—Flat

The spine shows no curves in the full view, and there appears to be an equal amount of mass on both sides of the Center Line.

Angled View of the Back—Depth

Now the back looks alive. The spine appears to wind its way down the neck to the hips. The mass on either side of the Center Line appears to be uneven, which adds interest. (The spine is, in reality, at the "true center" of the figure, but due to perspective, we see it as left of center.)

The Bells and Whistles

Here's another effective way to make the figure appear to have depth. We turn the back even more toward us to create what is called a three-quarter rear angle. Now we've reversed things. Instead of mostly seeing the front of the torso and a bit of the back, we are mostly seeing the back and only a bit of the torso.

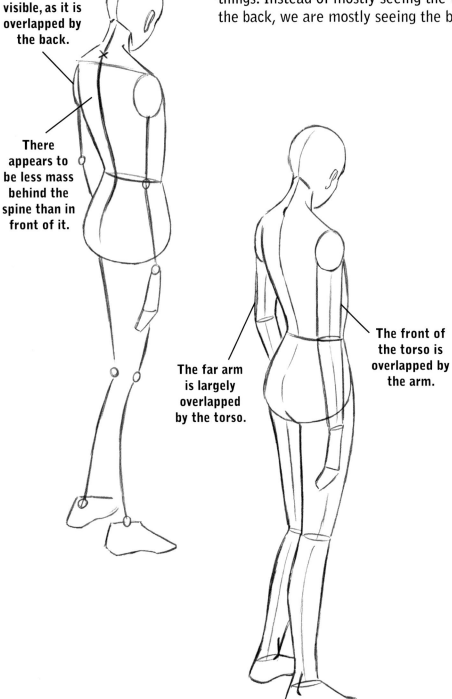

The far shoulder is only partially visible, as it is overlapped by the back.

There appears to be less mass behind the spine than in front of it.

The far arm is largely overlapped by the torso.

The front of the torso is overlapped by the arm.

When the skeletal construction is fleshed out, the appearance of depth becomes more apparent.

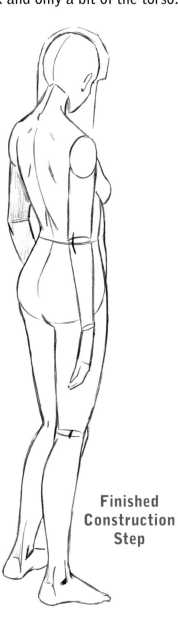

Finished Construction Step

POSE POINT

From the ¾ rear view, the foot shows two angles.

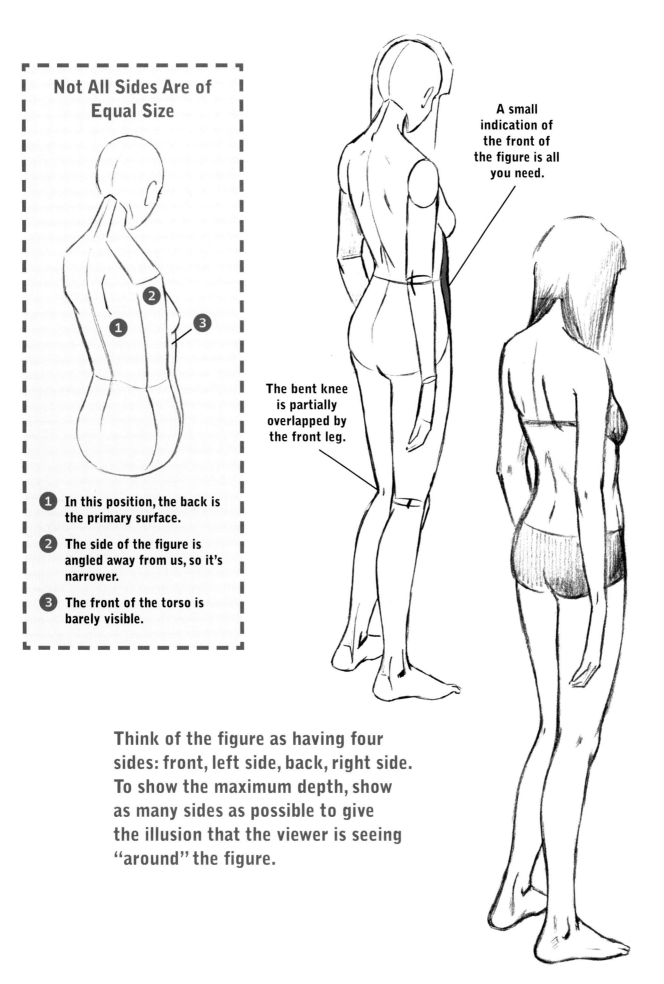

Not All Sides Are of Equal Size

1. In this position, the back is the primary surface.

2. The side of the figure is angled away from us, so it's narrower.

3. The front of the torso is barely visible.

A small indication of the front of the figure is all you need.

The bent knee is partially overlapped by the front leg.

Think of the figure as having four sides: front, left side, back, right side. To show the maximum depth, show as many sides as possible to give the illusion that the viewer is seeing "around" the figure.

The Hidden Half

By concealing part of the figure, you create the illusion of depth. Here's how it works: the arm and leg on the left side of the figure are in full view. But the arm and leg on the right side of the figure are only partially visible, because they are overlapped. This suggests to the viewer's eye that the near side is overlapping the far side, which is a definition of depth.

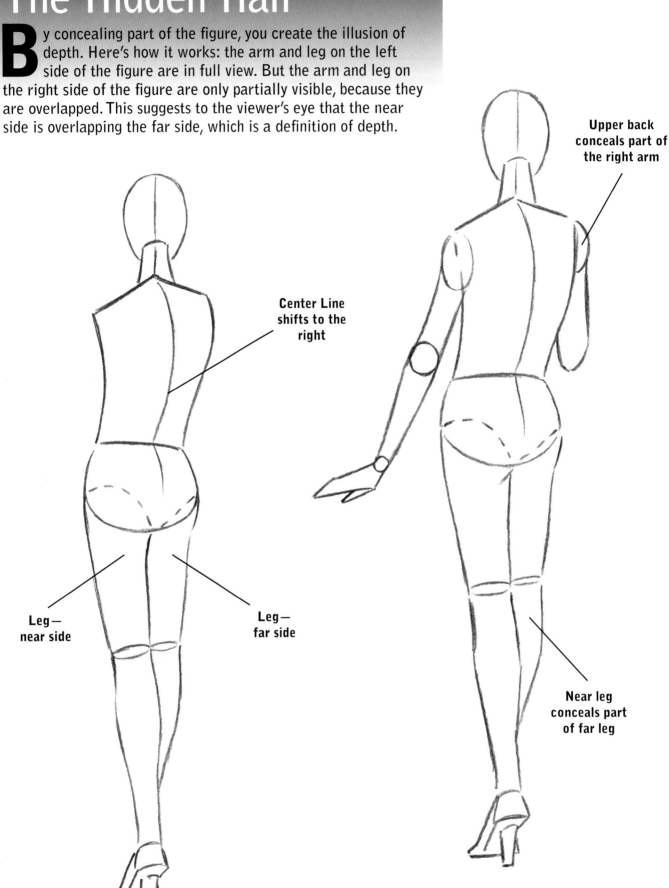

Upper back conceals part of the right arm

Center Line shifts to the right

Leg— near side

Leg— far side

Near leg conceals part of far leg

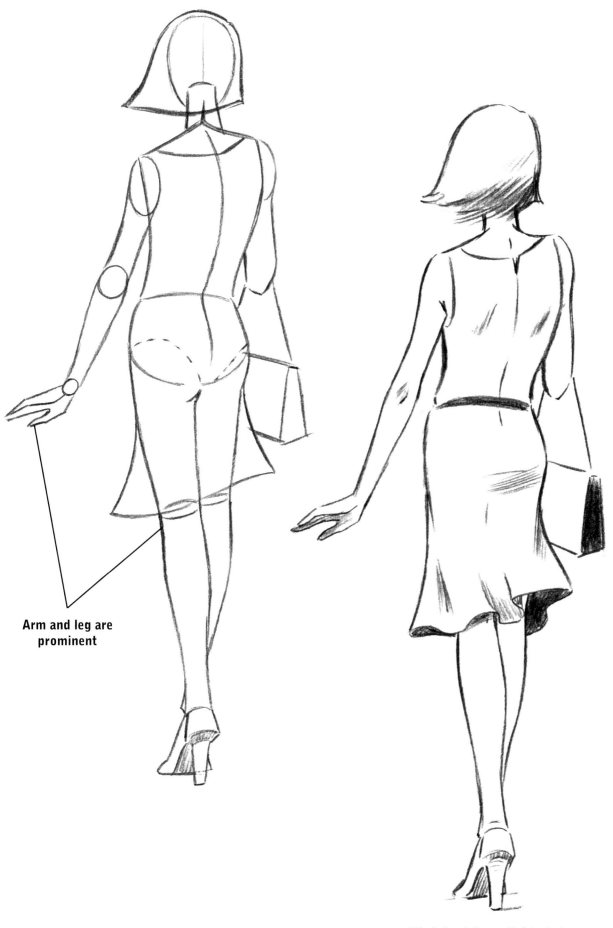

Arm and leg are prominent

Finished Pencil Sketch

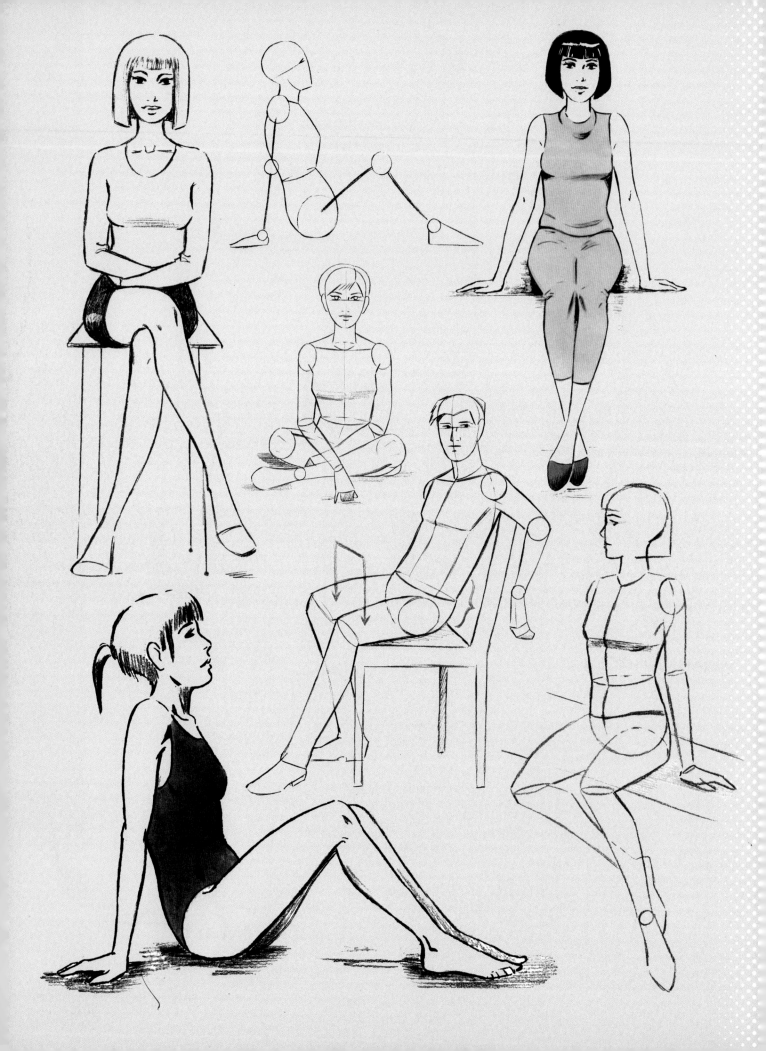

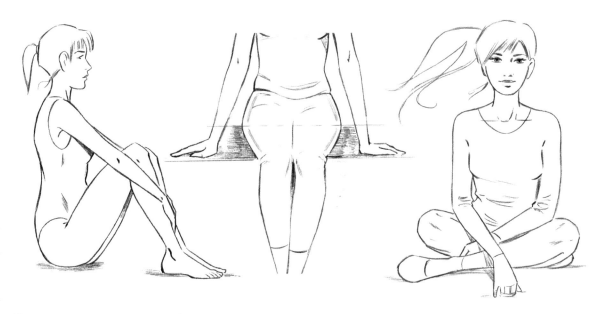

Seated Poses

With seated figures, the hips do the work that the legs do on standing poses. Namely, they support the body's weight. Therefore, the legs generally experience less stress, which means fewer lines of definition. However, some leg poses create definition without any stress, such as when one leg rests on top of another. In such a case, the top leg is compressed, which causes it to show lines of definition.

Posture

We generally think about posture as it relates to standing poses. But posture is a key element in seated poses, too. A straight back in a sitting pose looks pleasing. More people sit with a straight back than stand with a straight back. Softening the seated posture so that it looks relaxed creates interesting variations.

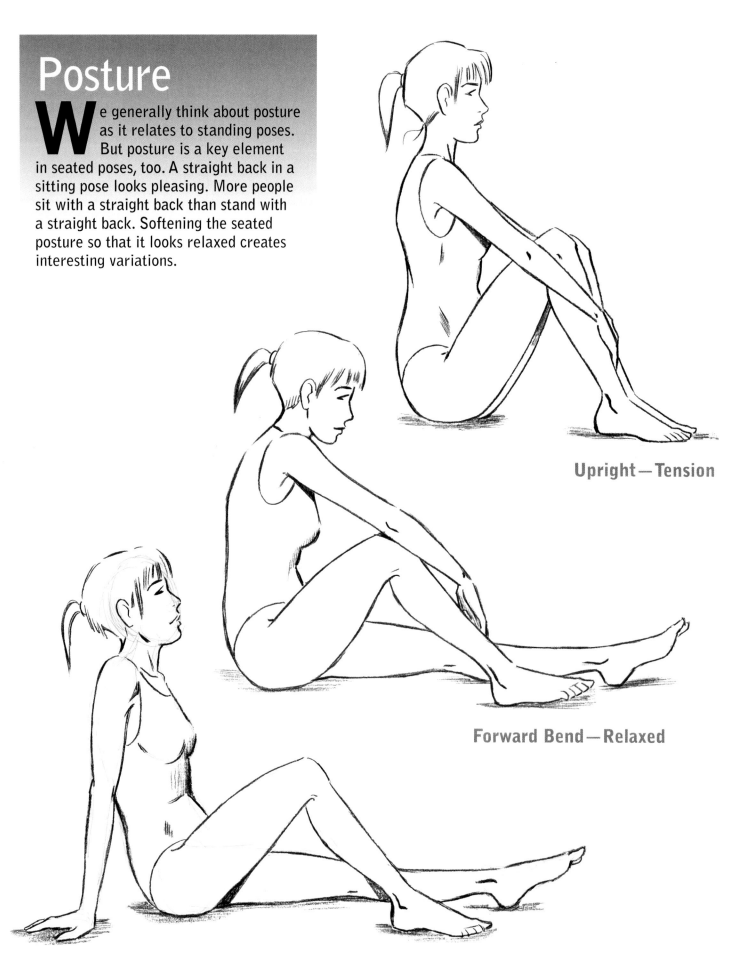

Upright—Tension

Forward Bend—Relaxed

Backward Bend—Relaxed

Sitting on the Ground

When the figure sits on the ground and leans back without an assist from a chair, the arms do the work that the legs do in a standing pose: they prop up the body. Let's look at some of the dynamics that this brings into play.

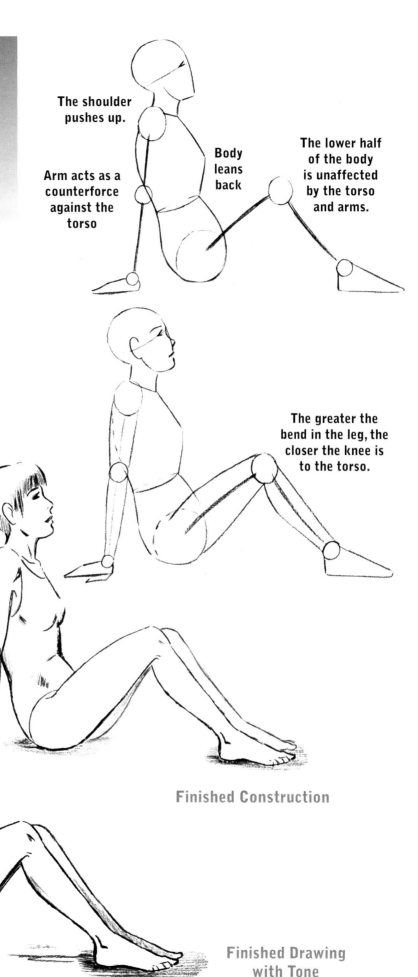

The shoulder pushes up.

Arm acts as a counterforce against the torso

Body leans back

The lower half of the body is unaffected by the torso and arms.

The greater the bend in the leg, the closer the knee is to the torso.

Finished Construction

Finished Drawing with Tone

117

Sitting in a Chair— Side View

Why is it that when you go to a restaurant with a group of people, you're always the one who gets the chair with one short leg? Or is it just me? Anyway, a figure, sitting in a chair, is the most common seated pose. Let's see how we can optimize this position.

Side View

Lots of people draw a seated person in a strict side view. Not exactly riveting, is it? I call this pose the "eye exam" pose. If you don't want your figure to look like a patient in a doctor's office, you're going to have to make a few adjustments.

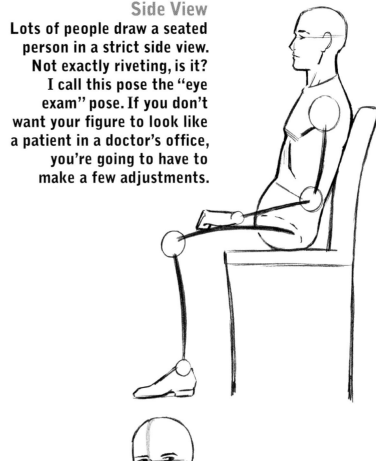

Side View—Angled Toward Viewer

If we turn the chair just a few inches to the left, we suddenly have depth. We can keep the same, basic position of the torso in the strict side view while creating variety with the arm and legs.

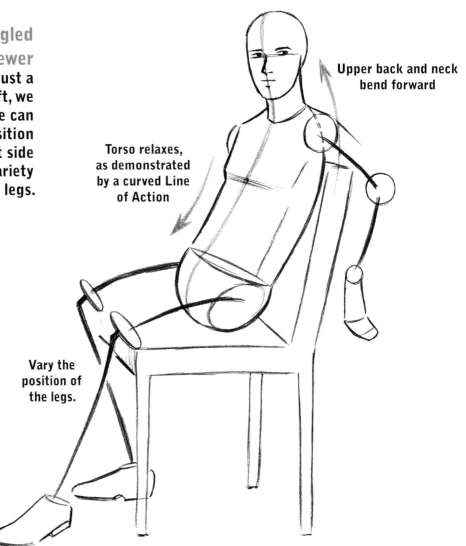

Upper back and neck bend forward

Torso relaxes, as demonstrated by a curved Line of Action

Vary the position of the legs.

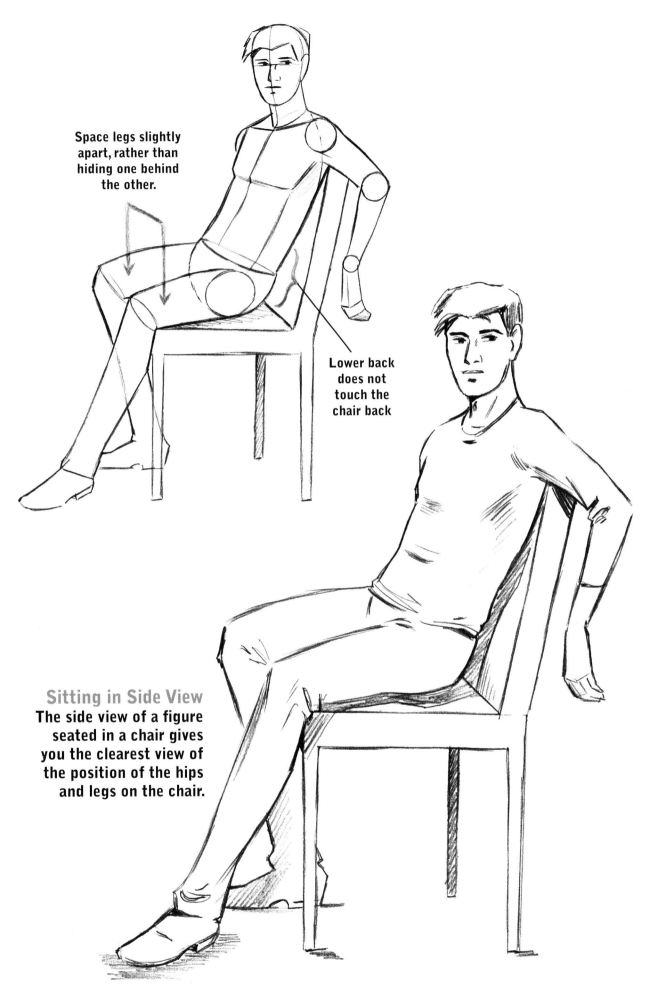

Space legs slightly apart, rather than hiding one behind the other.

Lower back does not touch the chair back

Sitting in Side View
The side view of a figure seated in a chair gives you the clearest view of the position of the hips and legs on the chair.

119

Drawing crossed legs in a front, seated pose requires the understanding of the body's mechanics. It calls for a bit of analytic thinking to get the concept. But once you understand it, you can always put it into effect.

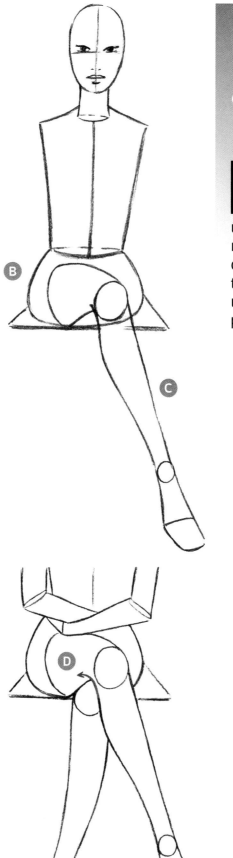

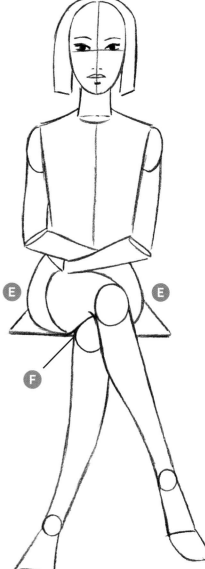

A The hip area widens under pressure.

B The upper leg swings around toward the opposite hip. Perspective makes the thigh appear shorter than it really is.

C The lower leg is drawn on a diagonal.

D The line of the upper leg, shown in red, continues into the upper thigh. This overlapping line creates the look of depth, which is necessary for the front angle.

E The upper legs widen and become the hips.

F The lower knee is partially masked by the upper leg.

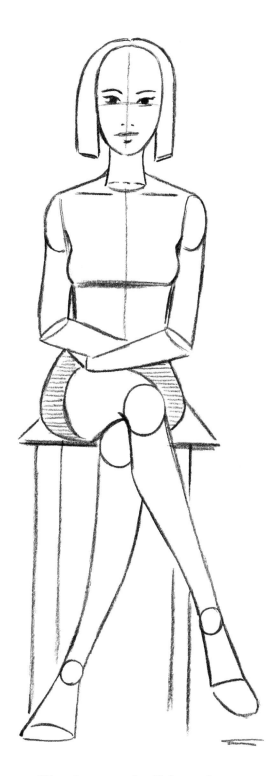

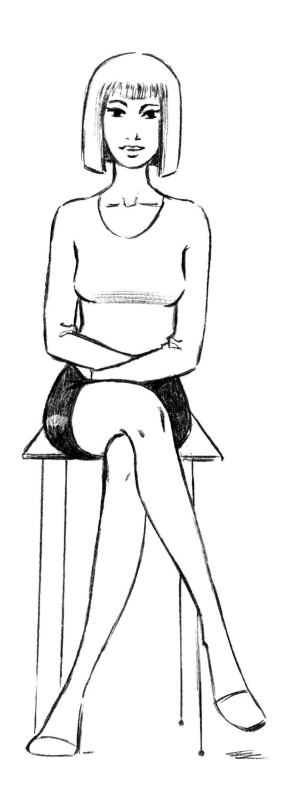

The two main things to remember with crossed legs are:
1. The top leg will hide part of the bottom leg.
2. Due to the angle (perspective), the thighs appear shorter than the lower legs.

POSE POINT

In a front view, objects that appear to come toward you look flattened. That's why the upper legs are truncated. The lower legs, on the other hand, are not traveling toward us, but up and down, vertically. Therefore, they are not as affected by foreshortening.

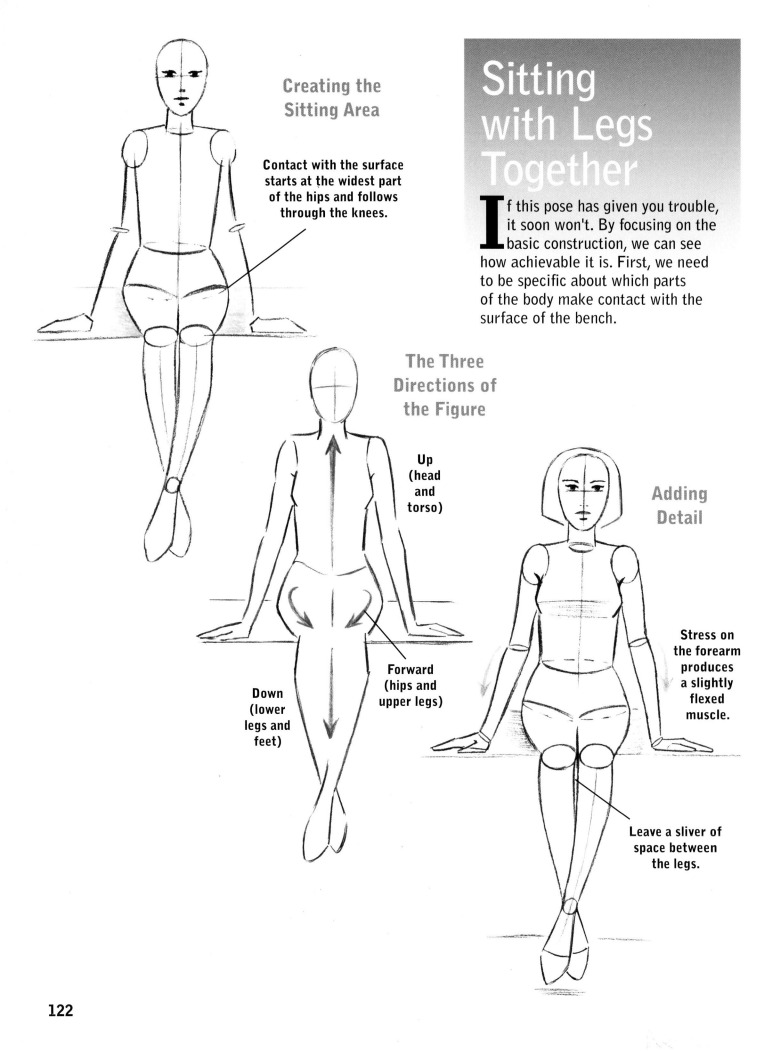

Creating the Sitting Area

Contact with the surface starts at the widest part of the hips and follows through the knees.

Sitting with Legs Together

If this pose has given you trouble, it soon won't. By focusing on the basic construction, we can see how achievable it is. First, we need to be specific about which parts of the body make contact with the surface of the bench.

The Three Directions of the Figure

Up (head and torso)

Forward (hips and upper legs)

Down (lower legs and feet)

Adding Detail

Stress on the forearm produces a slightly flexed muscle.

Leave a sliver of space between the legs.

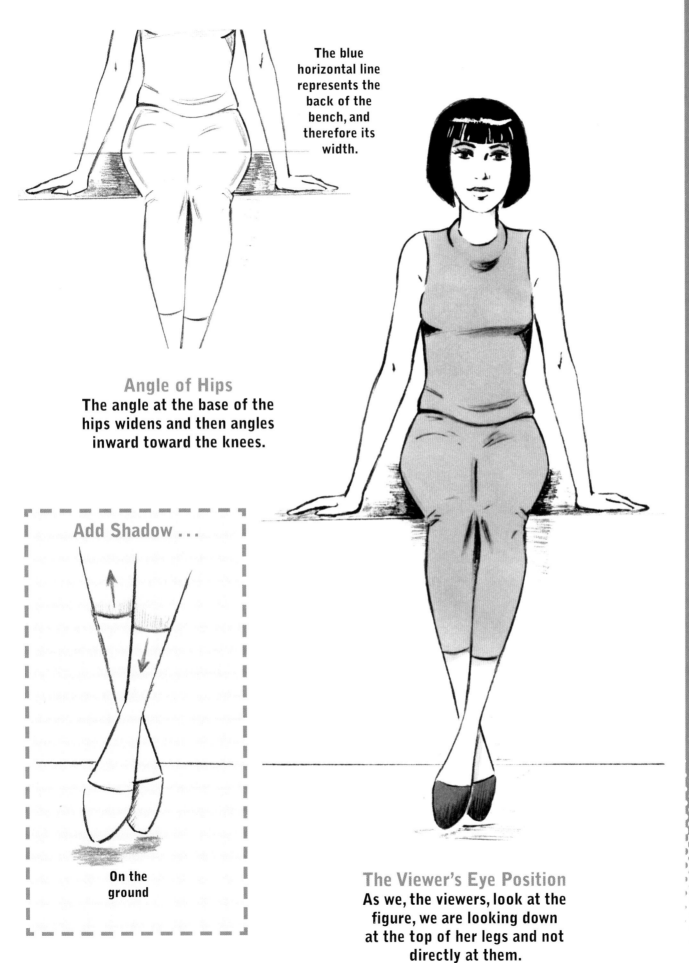

The blue horizontal line represents the back of the bench, and therefore its width.

Angle of Hips
The angle at the base of the hips widens and then angles inward toward the knees.

Add Shadow . . .

On the ground

The Viewer's Eye Position
As we, the viewers, look at the figure, we are looking down at the top of her legs and not directly at them.

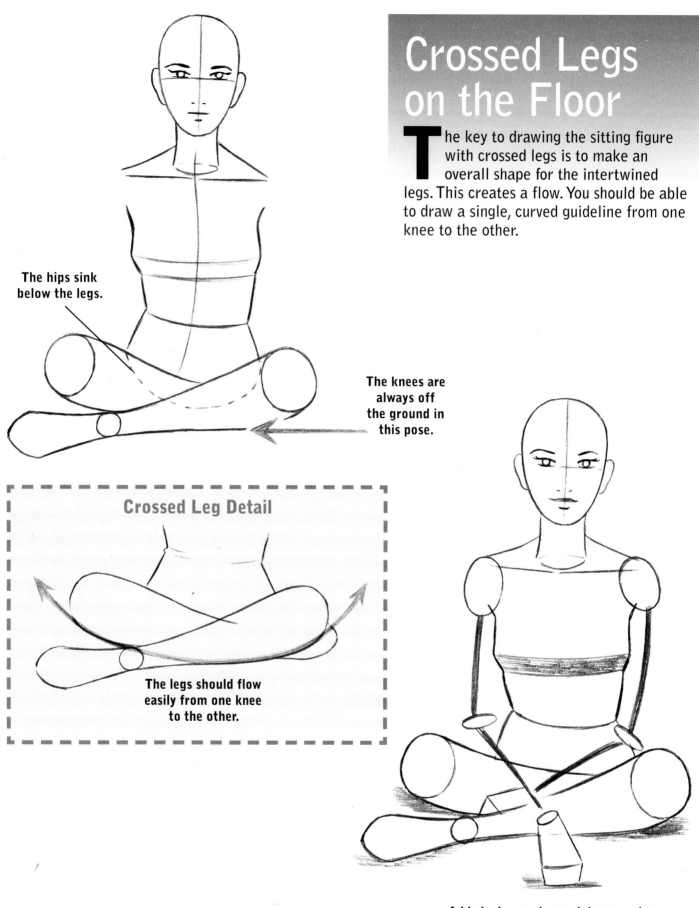

Crossed Legs on the Floor

The key to drawing the sitting figure with crossed legs is to make an overall shape for the intertwined legs. This creates a flow. You should be able to draw a single, curved guideline from one knee to the other.

The hips sink below the legs.

The knees are always off the ground in this pose.

Crossed Leg Detail

The legs should flow easily from one knee to the other.

Add shadow under each knee, under the foot, and where the hand makes contact with the ground.

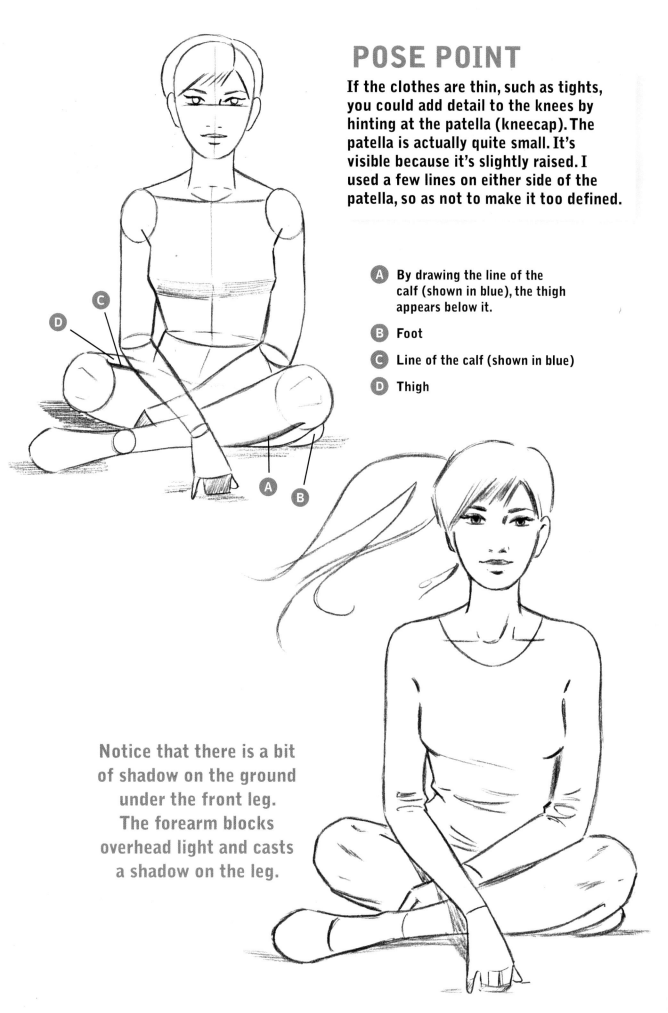

POSE POINT

If the clothes are thin, such as tights, you could add detail to the knees by hinting at the patella (kneecap). The patella is actually quite small. It's visible because it's slightly raised. I used a few lines on either side of the patella, so as not to make it too defined.

A By drawing the line of the calf (shown in blue), the thigh appears below it.

B Foot

C Line of the calf (shown in blue)

D Thigh

Notice that there is a bit of shadow on the ground under the front leg. The forearm blocks overhead light and casts a shadow on the leg.

125

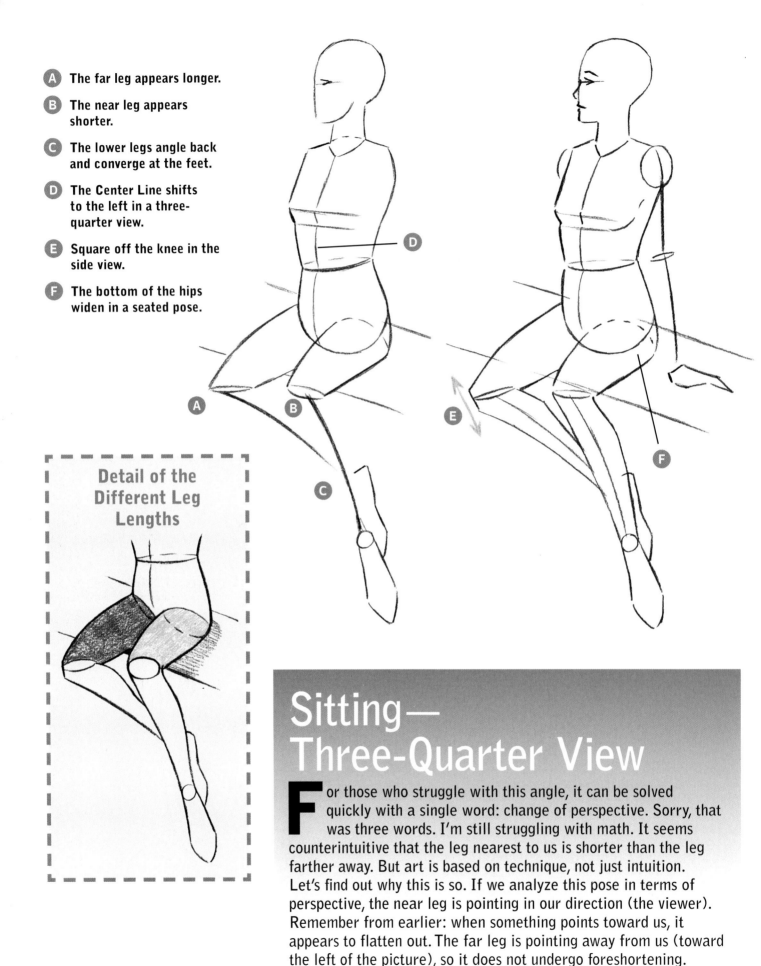

A The far leg appears longer.

B The near leg appears shorter.

C The lower legs angle back and converge at the feet.

D The Center Line shifts to the left in a three-quarter view.

E Square off the knee in the side view.

F The bottom of the hips widen in a seated pose.

Detail of the Different Leg Lengths

Sitting— Three-Quarter View

For those who struggle with this angle, it can be solved quickly with a single word: change of perspective. Sorry, that was three words. I'm still struggling with math. It seems counterintuitive that the leg nearest to us is shorter than the leg farther away. But art is based on technique, not just intuition. Let's find out why this is so. If we analyze this pose in terms of perspective, the near leg is pointing in our direction (the viewer). Remember from earlier: when something points toward us, it appears to flatten out. The far leg is pointing away from us (toward the left of the picture), so it does not undergo foreshortening.

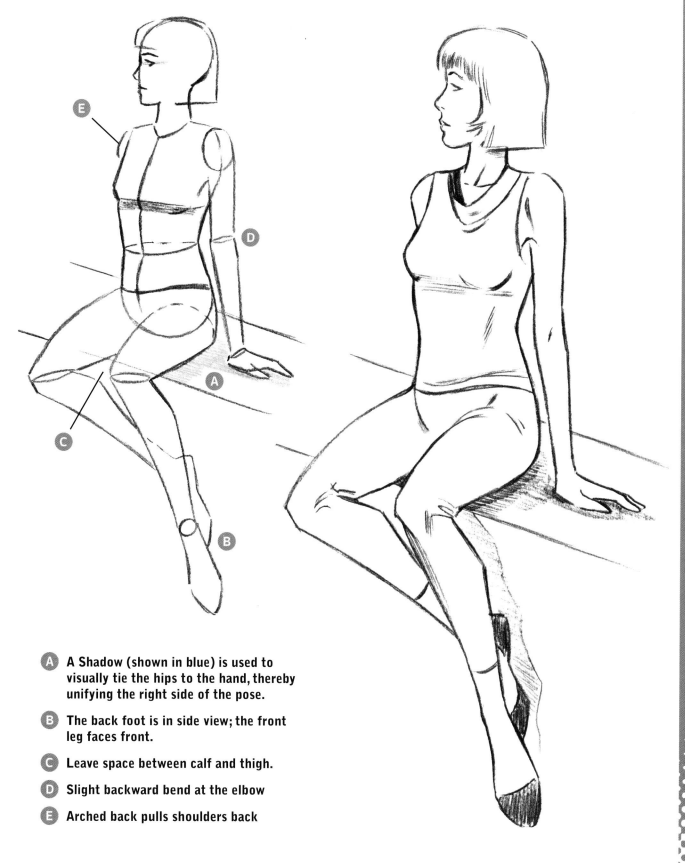

A A Shadow (shown in blue) is used to visually tie the hips to the hand, thereby unifying the right side of the pose.

B The back foot is in side view; the front leg faces front.

C Leave space between calf and thigh.

D Slight backward bend at the elbow

E Arched back pulls shoulders back

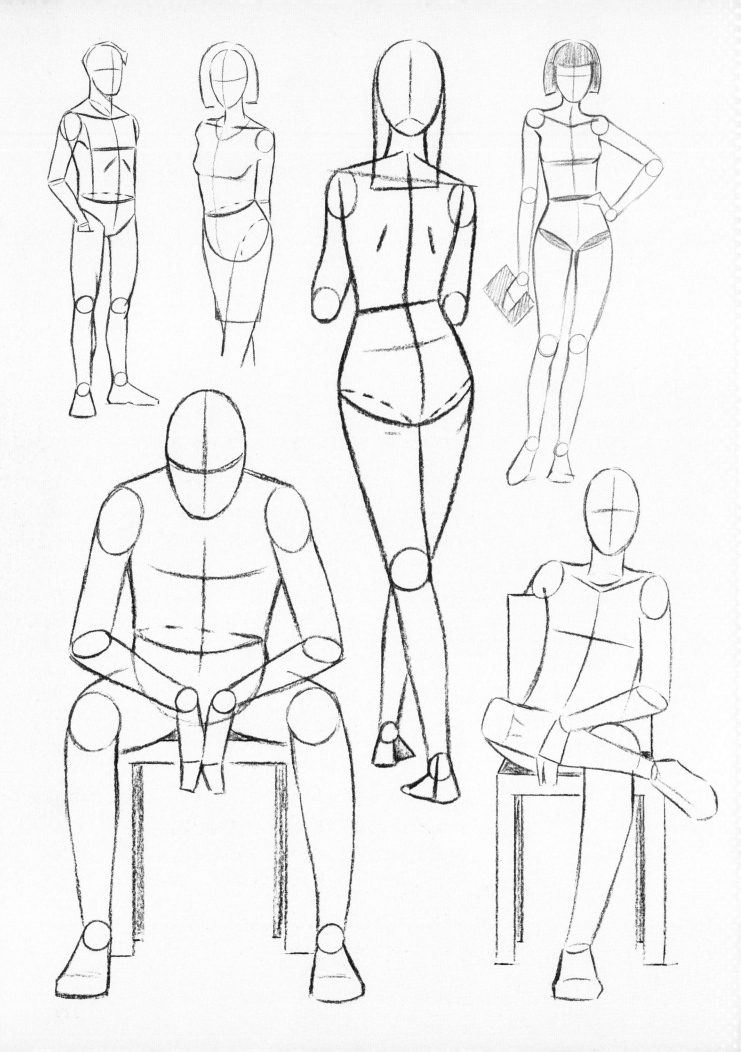

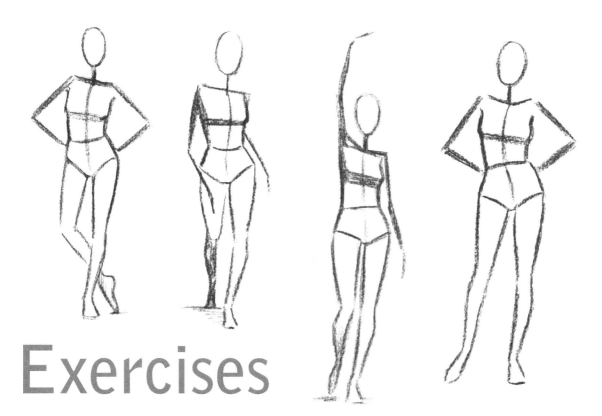

Exercises

For the last section of this book, I've created a variety of drawing exercises for popular poses. Some are completed figures, some are basic constructions, and some are rough sketches. At this point in your progress, you'll be able to recognize the principles and dynamics that are at play in these drawings.

We've covered a lot of territory in this book together. I know that, in addition to the techniques I have introduced to you, you will also find your own, unique way of solving problems. I invite you to tell me of your progress by visiting me on social media at my website (christopherhartbooks.com), on Facebook (facebook.com/LEARN.TO.DRAW.CARTOONS), or on my Youtube channel (youtube.com/chrishartbooks).

Front View

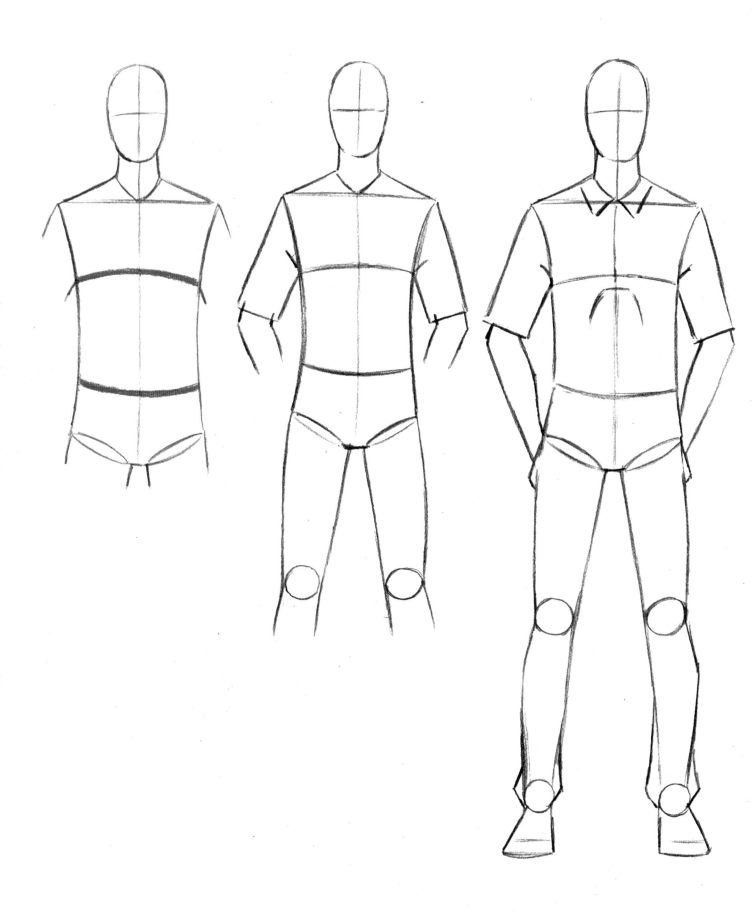

Three-Quarter View (Front)

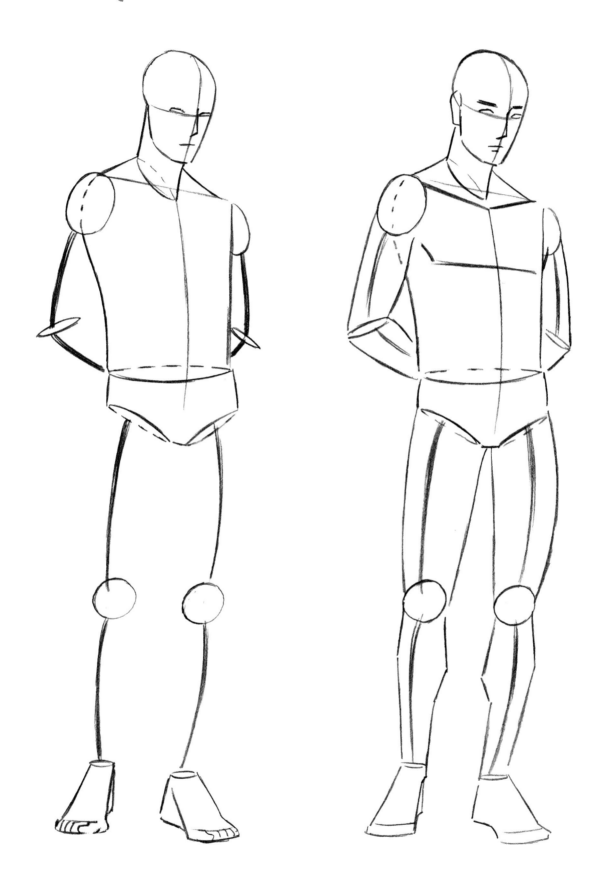

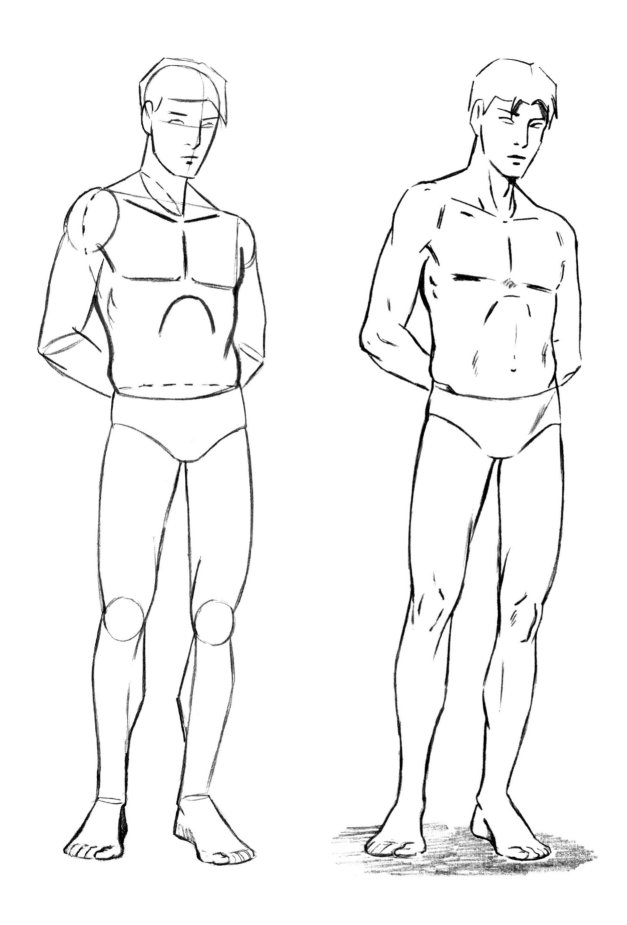

Three-Quarter View (Back)

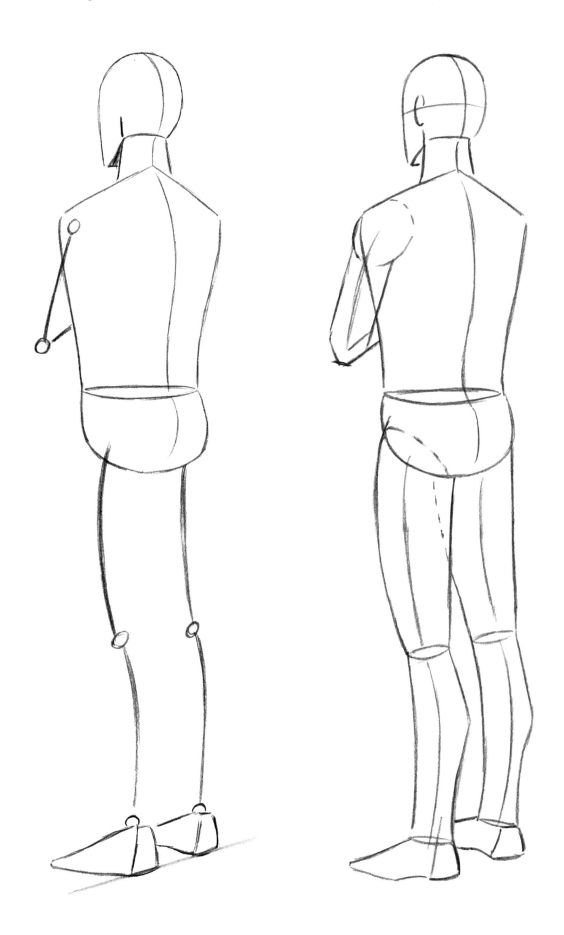

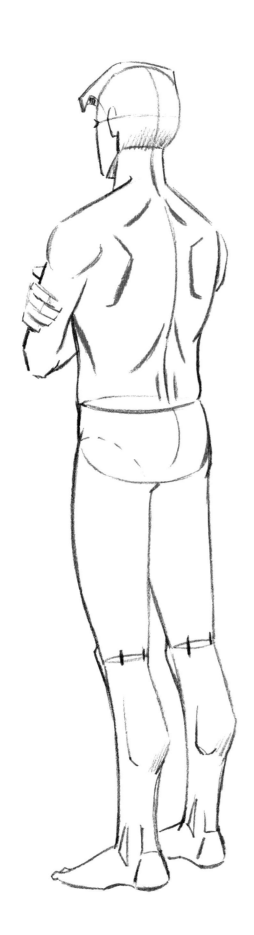
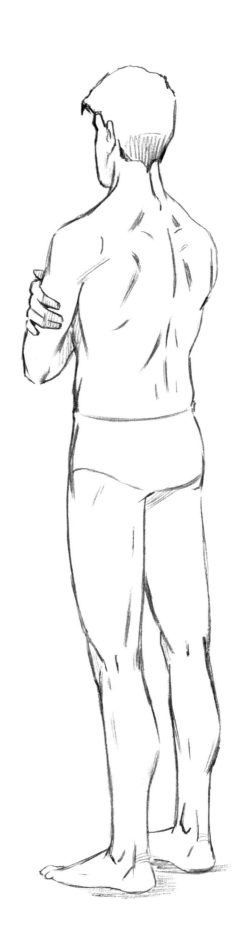

Turn a Pose into an Action

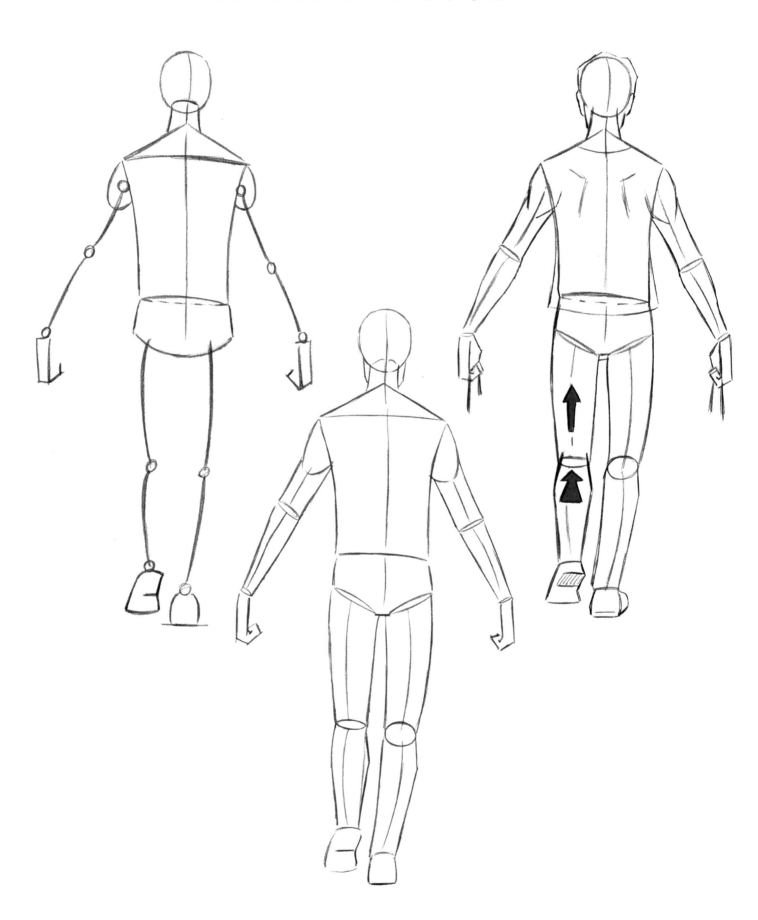

Standing Poses

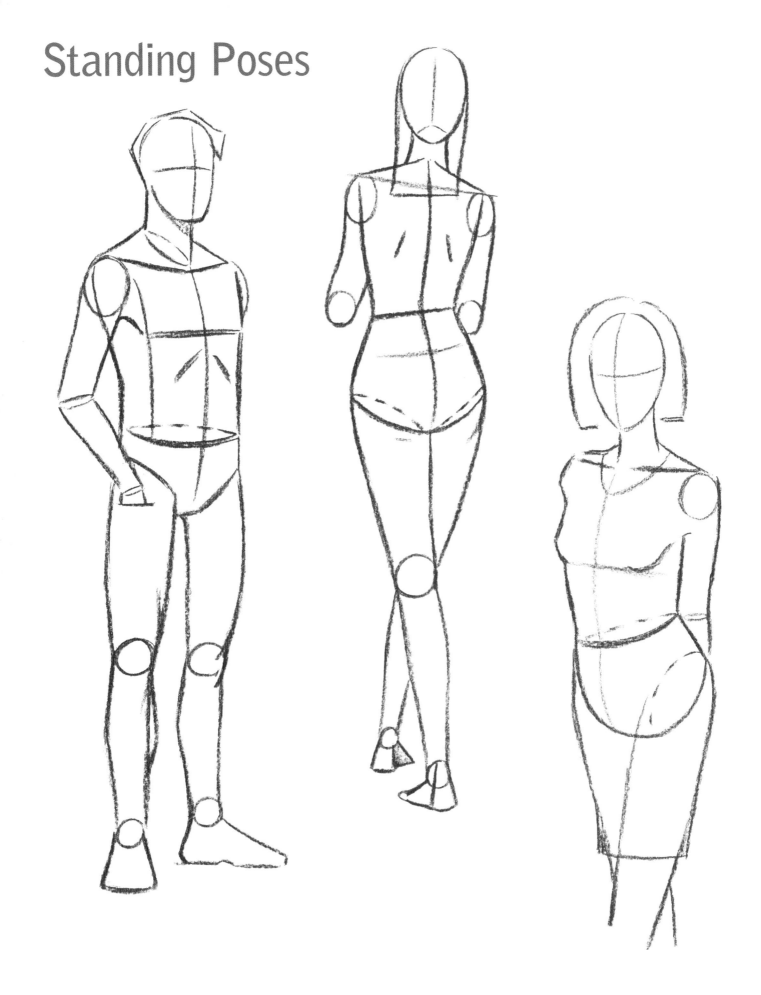

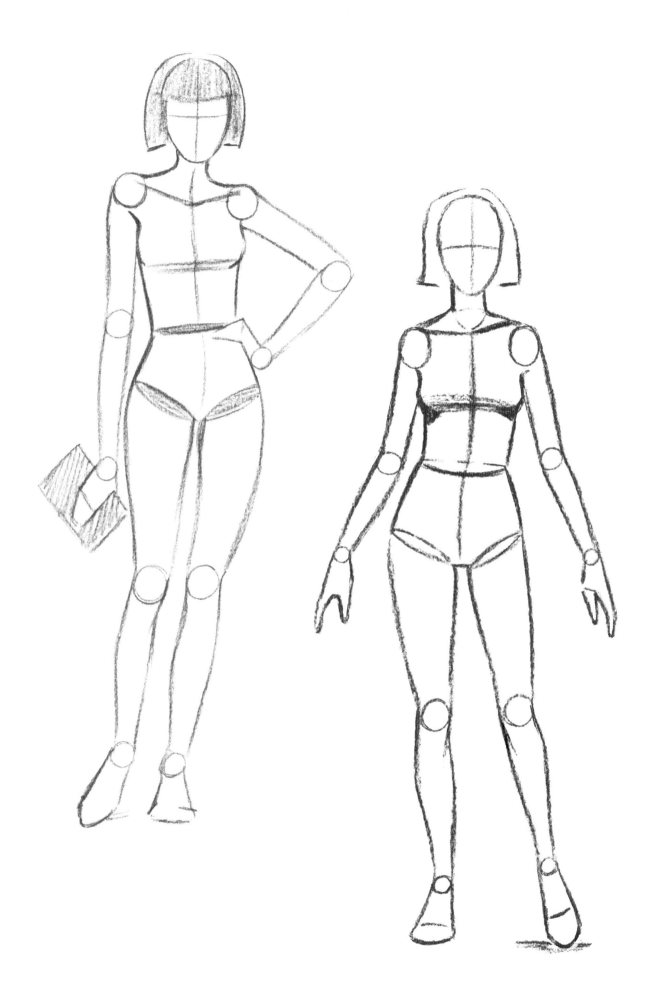

Seated Poses

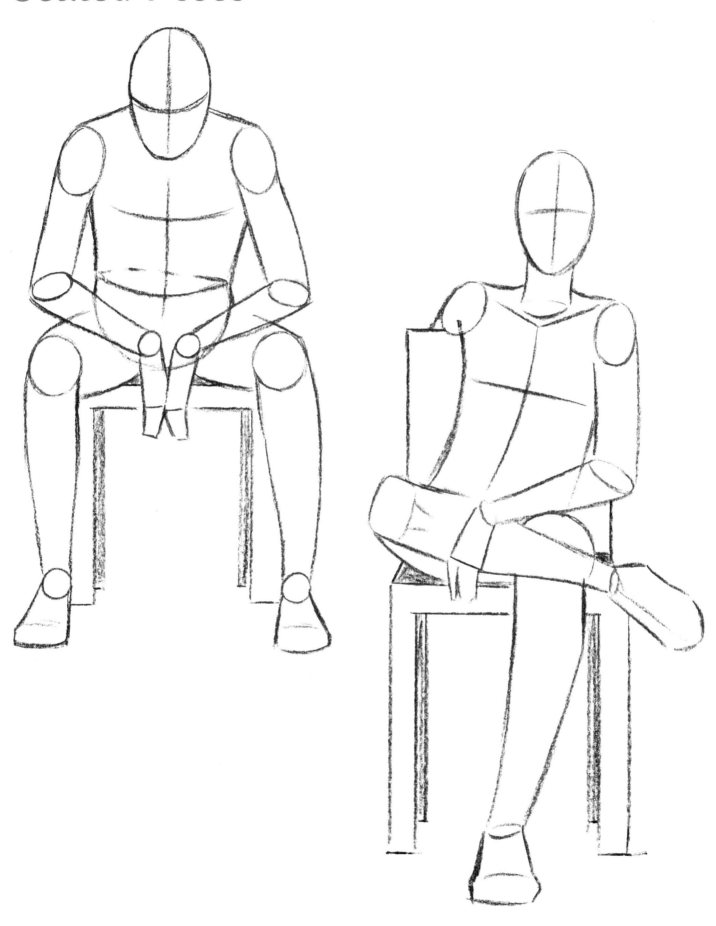

Variations

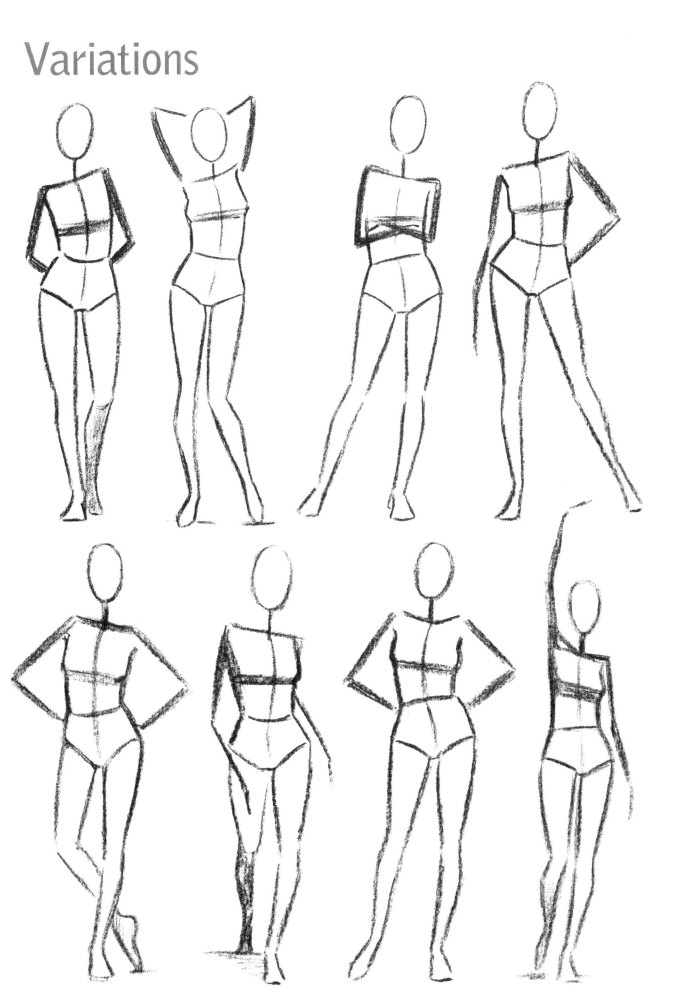

Rough Sketches

I've included some rough sketches so that you won't be under the impression (and self-imposed pressure) that you must draw everything perfectly on the first try. That couldn't be further from the truth. The only people who draw everything perfectly the first time are people who love everything they do.

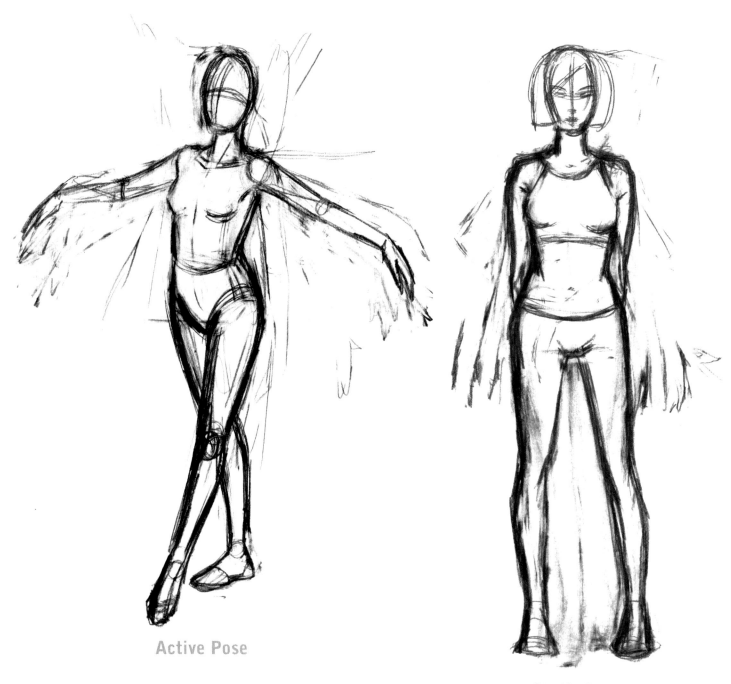

Active Pose

Static Pose

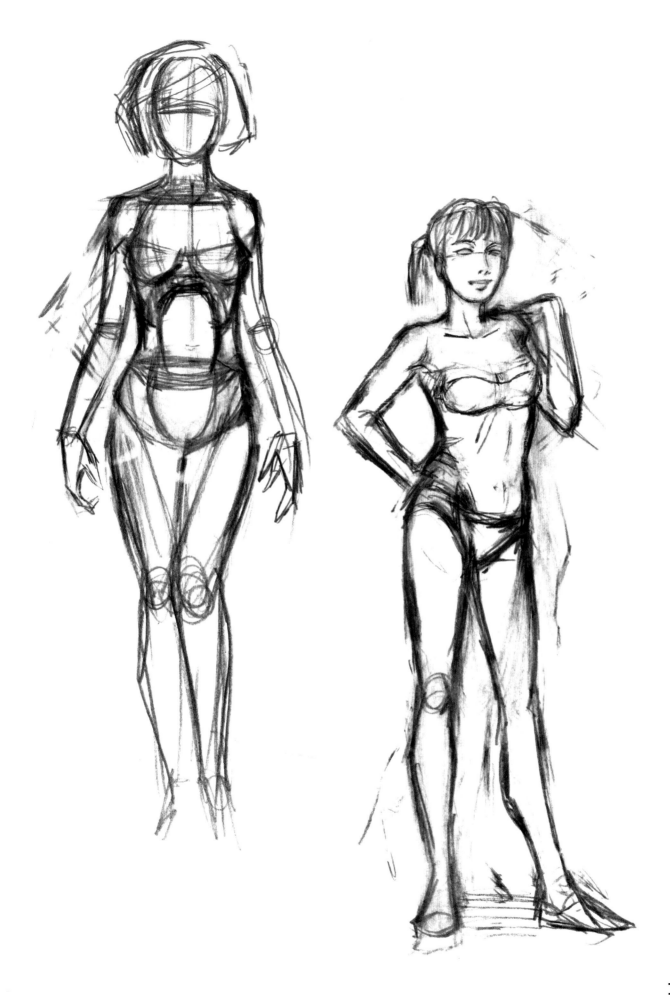